IMAGES
of America

FLAT ROCK

THE LITTLE CHARLESTON
of THE MOUNTAINS

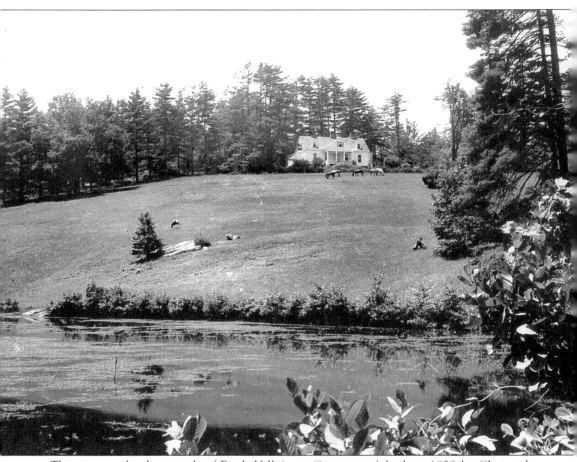

This is an early photograph of Rock Hill (now Connemara) built c. 1839 by Christopher Gustavus Memminger, the author of the Declaration of Immediate Causes. He chaired the committee that drafted the Constitution of Confederate States. The property was purchased by Ellison Adger Smyth in 1900. He changed the name to Connemara after an ancestral home in Ireland. In 1945 it was purchased by Carl Sandburg. It is now a National Historic Site operated by the National Park Service. (Courtesy Paula Steichen Polega and the National Park Service.)

On the cover: Taken on the steps of Sans Souci (Saluda Cottages), this photo is titled "The Gang, Flat Rock, NC, 1897." The photo was originally the property of Mrs. Alexander Rose. (Courtesy John Laurens III.)

FLAT ROCK

THE LITTLE CHARLESTON
of THE MOUNTAINS

Galen Reuther

ARCADIA
PUBLISHING

Copyright © 2004 by Galen Reuther
ISBN 978-0-7385-1657-8

Published by Arcadia Publishing
Charleston, South Carolina

Printed in the United States of America

Library of Congress Catalog Card Number: 2004104013

For all general information contact Arcadia Publishing at:
Telephone 843-853-2070
Fax 843-853-0044
E-mail sales@arcadiapublishing.com
For customer service and orders:
Toll-Free 1-888-313-2665

Visit us on the Internet at www.arcadiapublishing.com

This book is dedicated to the people of Flat Rock who have made this village a special place, and to Historic Flat Rock, Inc., whose goal it is to protect and preserve historic properties.

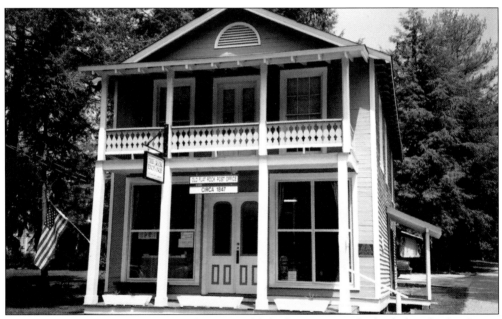

The first postal service in Flat Rock was established in 1829 with the help of John Davis, a veteran of the War of 1812 under Colonel Coffee. Davis came to Flat Rock in 1823 and established a mill and dwelling on property that would become the Argyle Estate. He appealed to Colonel Coffee for assistance, and with his help the post office was established, with Davis as the first postmaster. After years of being in local taverns, the post office was established in what is now called the Old Post Office, with the Reverend Peter Stradley as postmaster. It was the central gathering place for the community and a stagecoach stop for Col. Valentine Ripley's stagecoach from Greenville, South Carolina, to Greenville, Tennessee. It is now the office of Historic Flat Rock, Inc., and the non-profit Book Exchange.

CONTENTS

ACKNOWLEDGMENTS

It is difficult to capture the essence of a village that is so steeped in history. Fortunately, whenever I asked for assistance in gathering images and historical data, it was more than graciously given. There may be errors of omission, but I hope what I have included is indicative of Flat Rock's wonderful heritage. In addition to our present residents, I am most grateful to those who came before, those who created a settlement out of the wilderness, and then those who created a very special summer retreat. Flat Rock has evolved into an ideal four-season location in which to live, a location that echoes the past.

Especially helpful in this project were William P. Andrews, who added immeasurably to this book and never seemed to tire of my questions, and Charles Kuykendall, who gave me so much encouragement from the beginning of the project. Thank you so much to Louise Howe Bailey, Sally Hughes, John Laurens III, Sara Bowers Bowen, Dr. John Laurens II, Danny Ogletree, Mary and MacDonnell Tyre, and Debbie and Gene Staton, who shared their photographs, knowledge, and memories. Thank you to everyone who shared photographs for this work. The author's proceeds from the sale of this book go to Historic Flat Rock, Inc., to assist in preservation efforts.

Special thanks go to Historic Flat Rock, Inc., who opened their files for my use, and to my husband, Lee, for his unwavering support.

INTRODUCTION

The village of Flat Rock, nestled on a plateau in the Blue Ridge Mountains of Western North Carolina, lies 22 miles south of Asheville and is adjacent to Hendersonville. Named for the great expanse of flat rock, now partially covered from years of development, Flat Rock has beginnings that can be traced to the time of the Cherokee Nation. Historians have said that this tribe, known as the Mountaineers among American Indians, laid claim to much of the upper and northwestern area of South Carolina and all of North Carolina. Here they spent their summers, hunted, fished, traded wares, and held their ceremonial rites. Evidence has been found of their occupation, including the recent discovery of soapstone bowls carved by hand. Burial mounds have been noted and studied. A portion of the flat rock is exposed at the Flat Rock Playhouse, the state theatre of North Carolina.

The Revolutionary War was brewing and the Cherokee sided with the British against the hardy Americans. After the country won its independence, the Cherokee were a defeated people and found their vacationland was no longer theirs. North Carolina ceded all land that belonged to the Cherokee to the national government in 1783. Among the earliest settlers of record was Capt. Abraham Kuykendall, who had discovered Flat Rock during expeditions in search of Tories and Native Americans during the war. The government issued land grants to veterans who had served their country valiantly. Kuykendall entered a request for a land grant in 1779. Around 1790, land grants were issued to Captain Kuykendall and Col. John Earle. Captain Kuykendall and his family and servants moved to Flat Rock, and he went on to acquire thousands of acres. He ran an inn, a tavern, and a mill. Colonel Earle left his home at Earle's Fort in Landrum, South Carolina, and here he operated a gristmill and a lumber mill. Perhaps most importantly, Earle opened the Old Buncombe Turnpike or the Old State Road from Landrum. Although it was a very rough road, it was a great improvement over the trails worn by the traders and Native Americans.

About this time, settlers began to arrive. For the most part, they were of Irish-Scotch and English descent and were educated and self-reliant. These early pioneers were mostly farmers. By the early 19th century, Charleston was an important seaport, and the planting gentry had acquired great wealth. The plantations of the Lowcountry were most uncomfortable and unhealthy in the summer months because of high heat and humidity. After people in South Carolina began hearing of the superb climate in the mountains, the journeys of exploration began in earnest. It was in 1827 that Flat Rock's burgeoning as a summer colony really began. In search of a healthy climate, Charles and Susan Baring of Charleston arrived with their extended family. The Barings built Mountain Lodge on beautiful grounds at the top of a hill. It is acknowledged to be the oldest dwelling built by the Charlestonians. The Barings also built St. John in the Wilderness Episcopal Church, which to this day is of utmost importance to the village. Judge Mitchell King, also of Charleston, came in search of a healthy climate for his wife. He was also interested in finding a rail link from the Atlantic seacoast to the inland waterway. In 1829, Judge King purchased a sawmill tract including a modest house from John Davis, an early settler and a veteran of the War of 1812 under Colonel Coffee. When King built Argyle, the old Davis house was incorporated in the structure. Argyle is still owned by the King family.

Word spread and before long, Charlestonians were making the two-week journey to the mountains with their servants, traveling in wagons laden with supplies for the summer. In the 30 years prior to the Civil War, Flat Rock saw the construction of numerous grand estates. The houses were large and commodious in order to accommodate family and friends for lengthy stays. The houses were built on considerable acreage, at the end of long, tree-lined drives. There is no single style of architecture, resulting in a wonderful mix. This early Flat Rock became a distinctive and influential summer colony, populated by the who's who of the South. Summers were filled with parties and congeniality.

Charleston's social register joined descendants of signers of the Declaration of Independence (Edward Rutledge, Arthur Middleton, Thomas Heyward, and George Taylor). Flat Rock also included descendants of Third Continental Congress member Henry Laurens, whose family still calls Flat Rock home, as well as descendants of two members of George Washington's State Department, Thomas and Charles Cotesworth Pinckney.

Confederate Secretaries of the Treasury Christopher Gustavus Memminger and George Trenholm were residents of Flat Rock. Of all the influential people who came to Flat Rock, Memminger was the one most associated with the nation's history during its time of great crisis. He built his home, Rock Hill, at the base of Glassy Mountain, where he lived permanently during his retirement years. He and his wife had 17 children, 10 of whom reached adulthood, 4 of whom built homes here. The house and beautiful grounds, known as Connemara, are a National Historic Site run by the park service as a shrine to Carl Sandburg, whose writings include the immense biography of Abraham Lincoln.

To this day, we are fortunate to have most of the grand estates from the 19th century well cared for. The 20th century experienced development from retirees as well as summer residents, who have build wonderful "cottages" with long porches to catch the breezes. The Village of Flat Rock was incorporated in 1995 and the permanent population is 2,062 (2000 census). The summer population doubles in size. Our government is made up entirely of volunteers. The entire village of Flat Rock is a National Historic District.

Historic Flat Rock, Inc., was formed to protect and preserve the historic properties of the village. It is an all volunteer organization, and every other year it sponsors a tour of homes as its annual fund-raiser.

The village of Flat Rock was established in 1807. Named for the massive granite outcropping in the center of the village (visible at the Flat Rock Playhouse), Flat Rock is a National Historic Site.

One

HISTORIC HOMES *and the* CHARLESTON INFLUENCE

Acknowledged as the earliest estate, Mountain Lodge, built by Charles and Susan (Heywood) Baring, c. 1827, sits high on a hill commanding lovely views. Charles Baring, whose family was Baring Bank of London, came in search of a healthy climate for his wife and to escape the heat and humidity of the Lowcountry. On their extensive property, they also built a private chapel, St. John in the Wilderness, the oldest Episcopal church in Western North Carolina. Friends soon heard about the lovely climate and beautiful scenery and followed. This was the beginning of "the Little Charleston of the Mountains." Charles Baring sold everything to Edward Trenholm, who bequeathed the property to his daughter Henrietta Trenholm Baldwin. For a period of years, the estate was known as Heaven Trees and passed through several owners. In 1958 Newton Duke Angier and his wife, Jane Sherrill, bought the estate and returned the name Mountain Lodge. It was their home until 1972. (Courtesy Newton Duke Angier.)

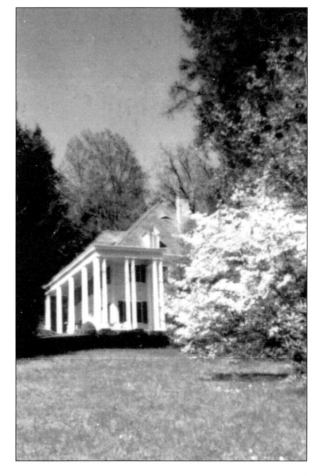

9

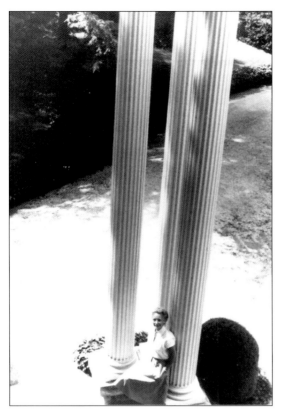

This is a wonderful photograph taken c. 1960 of Jane Sherrill Angier by the columns of her home Mountain Lodge. (Courtesy Newton Duke Angier.)

Built c. 1830 by Judge Mitchell King from Charleston, Argyle encompasses a small early dwelling that was part of the mill tract of John Davis. King's initial purchase included 1,390 acres, and he went on to purchase more acreage. He donated 50 acres to the City of Hendersonville on which the courthouse was built, and King is said to have participated in the efforts to have the County of Henderson created by the legislature in 1838. Argyle is the oldest estate in Flat Rock to be continuously owned by the same family. (Courtesy Alec C. King and Historic Flat Rock, Inc.)

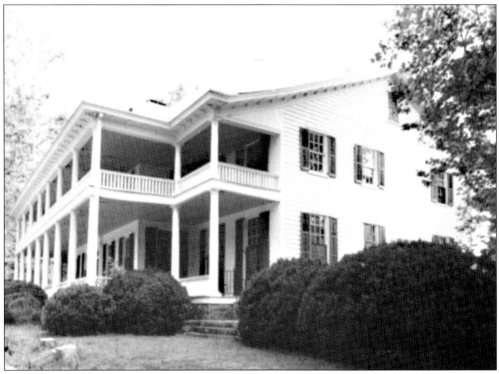

Tall Trees, formerly Green Lawn, was built c. 1840 by Arthur M. Huger and his bride, Margaret King. It was built on 80 acres of land given by Margaret's father, Judge Mitchell King, as a wedding gift. Arthur Huger was a descendant of one of the first Huguenot families to settle in Charleston in the 1680s. After Mr. Huger's death in 1852, the property was owned by Gov. Thomas Bennett of South Carolina. It is now the beautifully kept home of Mr. and Mrs. Clark Hecker. (Courtesy Mary and Clark Hecker.)

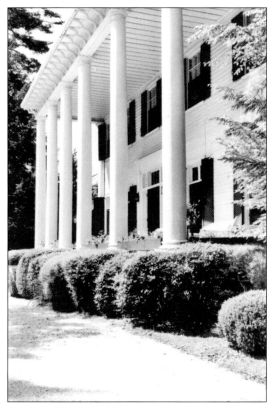

Pictured in 1951, the guesthouse at Tall Trees was thought to be the original kitchen house of the c. 1840s house. (Courtesy Mary and Clark Hecker.)

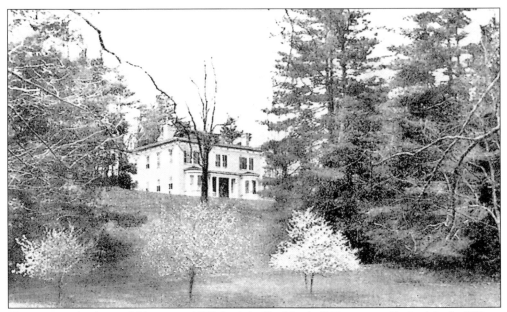

Here is an early photo of Glenroy c. 1850, built by Dr. Mitchell King, son of Judge Mitchell King, on land adjacent to his father's. The house was designed by a Scottish architect and shipbuilder, Freeman, from Charleston. The timbers for the house were cut and aged on the property. Dr. King conducted his medical practice from Glenroy. He was a much loved physician who traveled far and wide for 60 years to administer to the sick. At one time Glenroy had 23 outbuildings. (Courtesy Danny Ogletree.)

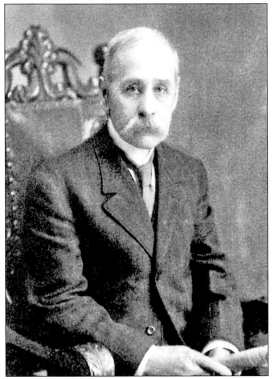

This is a photo of a portrait of Dr. Mitchell King. Dr. King was instrumental in bringing Floridians to the area. In the middle of an epidemic in the Jacksonville area, he convinced the local town fathers to encourage the sick to come here. During his travels and education in Europe, he had discovered that elevation and clean air did wonders for the ill. He was proved correct, and Floridians have flocked to Henderson County ever since. (Courtesy Georgia Historical Society.)

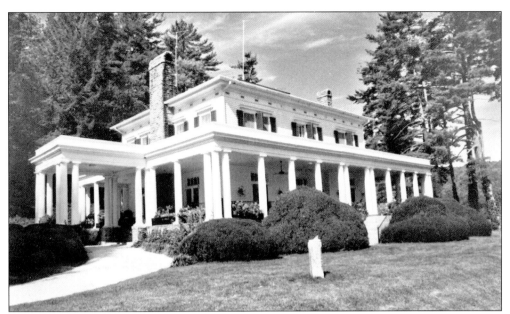

Purchased from the King family in 1924, Glenroy was turned into a showplace by the William Gordon McCabe family. They renamed the estate Kenmure after Kenmure Castle in Scotland, home of the Gordon clan. Mr. McCabe was a direct descendant of George Taylor, a signer of the Declaration of Independence. With its free-flying staircase, mile-long drive, spring-fed lake, and numerous improvements, Kenmure was considered by many to be the most beautiful home in Western North Carolina. Mr. McCabe offered the estate to President Eisenhower in 1954. It was regretfully refused because of Flat Rock's inaccessibility and isolation. Kenmure is now a private country club community. (Courtesy Mary McCabe Dudley.)

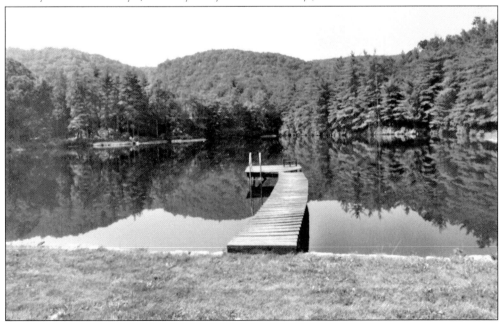

This is a picture of Kenmure's spring-fed lake where swimming was a pleasure during the summer months. The banks are lined with dogwoods and azaleas. (Courtesy Mary McCabe Dudley.)

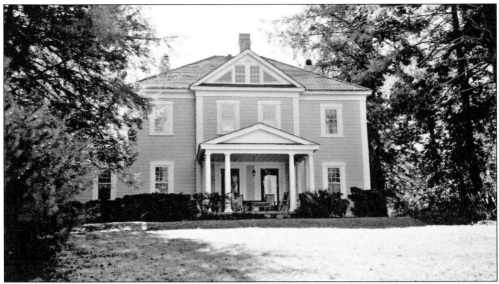

Begun c. 1828 with a small dwelling built by Frederick Rutledge, Brooklands is shown in this photo. The original dwelling is encompassed in what is now the guest house, pictured below. The builders of the main house and outbuildings were Charles and Mary Edmondston of Charleston. In 1841 it was purchased by Edmund Molyneaux, the British consul to Charleston. With the onset of the Civil War the property was abandoned. In 1881 it was purchased by Theodore and Louise (King) Barker, who restored and improved the house and added the Kirkwood King farm and adjoining land that Mrs. Barker had inherited from her father, Judge Mitchell King. This made Barker one of the largest landowners in Henderson County at that time. Although the entire estate was in Flat Rock, it has now been included in the town of Hendersonville. In 1917 it was bought by Henry Ficken of Charleston and his wife, Julia Ball, a descendant of Revolutionary War general William Moultrie. Mrs. Ficken was an avid gardener. During the summer, she supplied the flowers for St. John in the Wilderness Church every Sunday. (Courtesy Debbie and Gene Staton.)

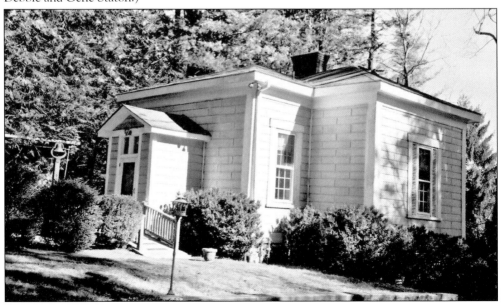

Frederick Rutledge, seen in this painting, built the early summer dwelling at Brooklands. (Courtesy Debbie and Gene Staton.)

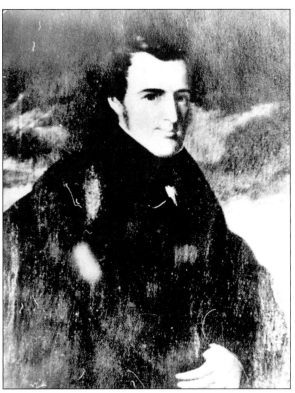

Major and Mrs. Theodore Barker, who owned Mulberry Plantation in South Carolina, are pictured on the steps of their Flat Rock home, Brooklands, c. 1898. (Courtesy Debbie and Gene Staton.)

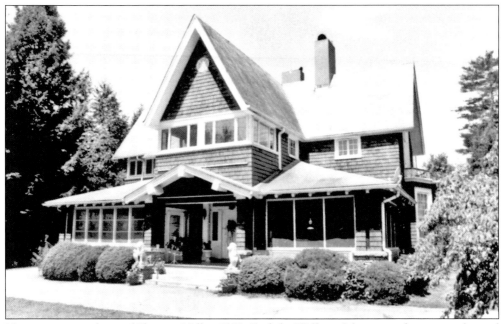

Here is a recent photo of Pleasant Hill c. 1839. Built by William Johnstone, the estate adjoined that of his father's estate, Beaumont. Andrew Johnstone and C.G. Memminger together worked to open Little River Road, providing much better access to both sides of the village as well as to Pleasant Hill.

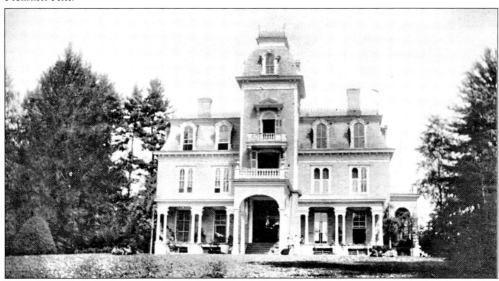

Built by Count Joseph Marie Gabriel Xavier de Choiseul, French consul to Charleston and Savannah, Saluda Cottages, c. 1836, was originally a modest house with accommodations for servants. The count and countess and their family lived here until c. 1841 when they built what is now Chanteloup. After several owners, it was purchased c. 1890 by Gen. and Mrs. Rudolph Siegling of Charleston. He was publisher of the Charleston *Post & Courier*. During their ownership, the house was greatly expanded and enhanced. The Sieglings changed the name to San Souci. It was later owned by Izard Middleton, a descendant of one of the 1670 land proprietors of South Carolina. (Courtesy Mrs. Lloyd Guyton Bowers.)

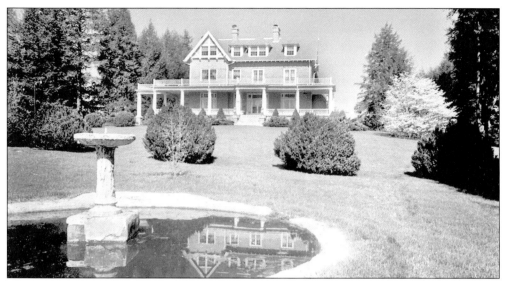

Built by Andrew Johnstone, a rice planter from Georgetown, South Carolina, Beaumont ("beautiful mountains") dates to c. 1839 and originally sat on 800 acres. The house is made of granite quarried in Flat Rock. Together with C.G. Memminger, Johnstone opened the Little River Road in 1850. In 1909, Beaumont was purchased by Frank Hayne, who added beautiful gardens. He was in partnership with Hugh Vincent, who bought Teneriffe, and they cornered the cotton market of the day. It has been mentioned that Elvis Presley tried to buy Beaumont in 1977, but the deal never came together. (Courtesy Mrs. Elizabeth R. McCoy.)

Built c. 1846 by the Reverend Charles Cotesworth Pinckney of Charleston, Piedmont was originally a two-story house made of 22-inch granite walls quarried on the premises. Pinckney's father was the ambassador to the Court of St. James, appointed by George Washington. After the Civil War, Piedmont was purchased by Henry I. Middleton, descendant of Arthur Middleton, one of the 1670 land proprietors of Charleston, and of Henry Middleton, founder of the Middleton Gardens. The long driveway is planted with 2,000 hydrangeas. In 1949, the house burned and was rebuilt using the original stone. (Courtesy George W. Phillips.)

Elliott Place was built *c.* 1877 by Col. William Elliott, U.S. senator from Beaufort, South Carolina. It was built on a portion of a large tract of land that was settled by the Elliott family *c.* 1830s, and it has a beautiful view of Highland Lake. The house has the romantic and carefree look of days gone by. For many years it was the summer home of Emily Whaley, much admired gardener and author of *Mrs. Whaley and her Charleston Garden* and *Mrs. Whaley Entertains.* Elliott Place is now the charming summer home of her daughters Marty Whaley Cornwell and Emily Whipple. (Courtesy Marty Whaley Cornwell and Emily Whipple.)

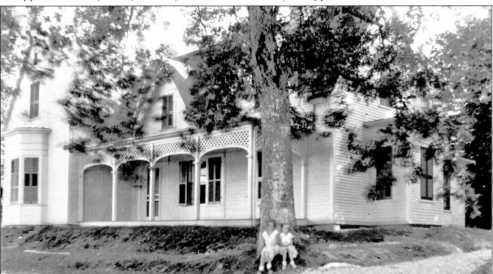

Dunroy was built by David Williams, a rice planter from Camden, South Carolina, whose wife was the sister of Mary Boykin Chestnut, author of *Diary from Dixie.* Mary Boykin Chestnut's husband was Jefferson Davis's aide during the Civil War. In later years Dunroy was owned by Mrs. James Rutledge and then her daughter, Mrs. Julius Heyward, descendants of a signer of the Declaration of Independence. Maj. Gen. Campbell King, grandson of Judge King, purchased the estate in 1933. It then went to his son Duncan Ingram Campbell King, fondly known as Dr. Dick King, the name "Dick" reflecting his initials. (Courtesy Historic Flat Rock, Inc.)

This is a wonderful picture of Richard Henry Lowndes and Susan Middleton Parker Lowndes in front of their home, Diamond in the Desert, *c.* 1846. Mr. Lowndes purchased the tract of land and the house that Charles Baring had built as a parsonage. The Lowndeses added the lattice work and the verandah. It was on this site that Mr. Lowndes raised the first Confederate flag flown in North Carolina in the War Between the States. The house burned in 1960. (Courtesy the Lowndes and Burke families.)

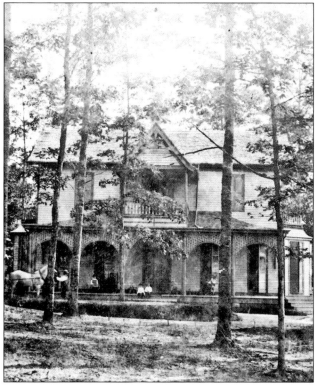

This is an early photo of The Rock, which was part of the Diamond in the Desert property. Richard Henry Lowndes leased The Rock property to his son Richard I'on Lowndes in 1884, and it is believed the house was built shortly thereafter and named for its proximity to "the great flat rock." Richard Henry Lowndes conveyed the property to Richard I'on Lowndes's children in 1902. Today it is the home of the Flat Rock Players and is called The Lowndes House. (Courtesy the Lowndes and Burke families.)

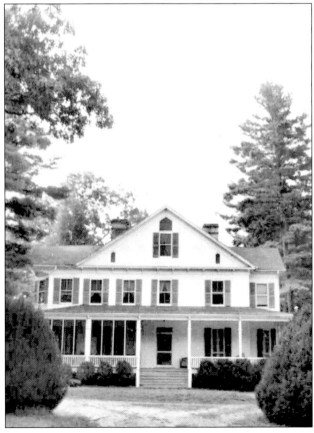

No exact date is known for the erection of the Parsonage, but in 1853, Edward Trenholm deeded 11 acres to St. John in the Wilderness Church for the purpose of building a parsonage for the church. It is made of granite quarried in Flat Rock. (Courtesy Historic Flat Rock, Inc.)

The land upon which Pinecrest was built, c. 1885, was once part of a 400-acre tract belonging to The Flat Rock Hotel. The builder of Pinecrest was Judge Charles H. Simonton of Charleston. For many years the property was a working farm, successfully operated by Allen E. Wood. Among the outbuildings were a stone dairy, a smokehouse, a bathhouse, a garage, a chauffeur's house, and a single-story house used in the late 20th century as a kiln house. The estate is presently being refurbished. (Courtesy Mr. and Mrs. Jeff Bowen.)

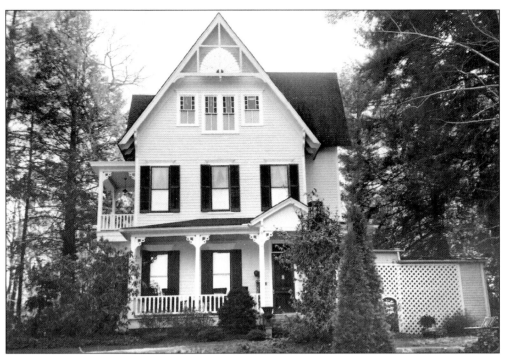

Built by Dr. Allard Memminger, the 16th child of Christopher Gustavus Memminger, Enchantment, c. 1887, is a tall stately house overlooking Jordan's Mill and lake. The house reflects a German influence and sits tall and proud. The interior of the house boasts beautiful woodwork, and the stained glass windows are original to the house. Dr. Memminger tended patients in the house for many years from his office, which is now a library. (Courtesy Mary and MacDonnell Tyre.)

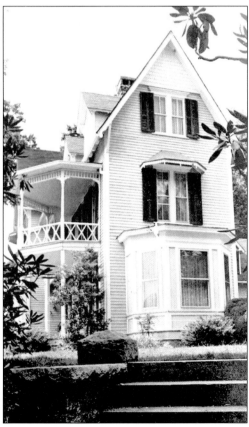

Built by Edward Read Memminger, the 17th child of C.G. Memminger, this gay 1890s house, Tranquility, was built as a gift for his bride. It is tall and bright with many porches. Edward Memminger collected rare plants in the lovely gardens, and when he died, 1,000 rare plant specimens were given to the University of North Carolina. The house looks out on Glassy Mountain and was the site of the well documented Civil War story reported in *Seven Months a Prisoner* by John V. Hadley. Mr. Memminger wrote the first historical sketch of Flat Rock as a birthday gift for his daughter. (Courtesy Historic Flat Rock, Inc. and Dr. and Mrs. M. MacDonald.)

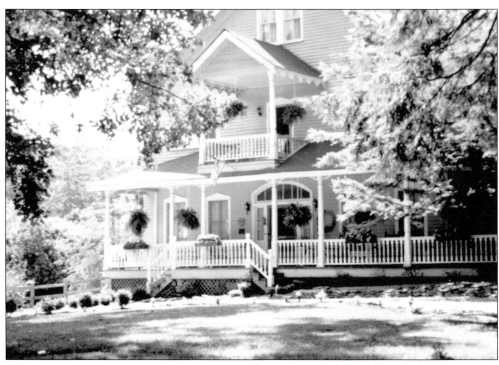

This is a recent photo of Five Oaks, now the Flat Rock Inn, built by the Reverend Withers Memminger, Christopher Gustavus Memminger's son, a pastor from Charleston. Five Oaks was built c. 1888. In 1911 it was purchased by Thomas Grimshawe from England. He and his wife, Elizabeth, lived here until 1930, when it went to their daughter, Greta Grimshawe, and her husband, Campbell King Sr., as a wedding gift. It is now operated as a fine bed and breakfast. (Courtesy Sandy and Dennis Page.)

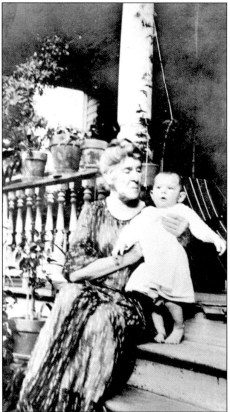

Elizabeth Boulton Grimshawe holds her grandson Campbell King on the steps of Five Oaks. (Courtesy Sandy and Dennis Page.)

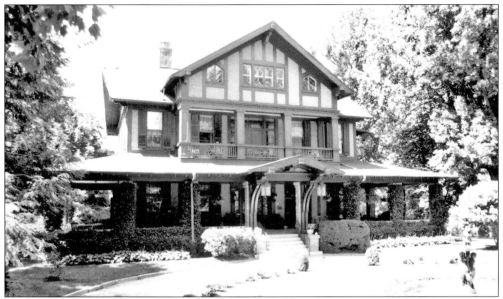

Known as one of the most beautiful estates in Flat Rock, Teneriffe was named for a Canary Island by its builder, Dr. J.G. Schoolbread. Teneriffe, c. 1852, is a fine example of an English country estate. In 1883 Charles Albert Hill, an Englishman and Charleston cotton broker, bought the property and expanded the gardens. The estate, now the property of Mr. and Mrs. Marvin Seibold, is of grand proportions and is beautifully maintained. (Courtesy Helen and Marvin Seibold.)

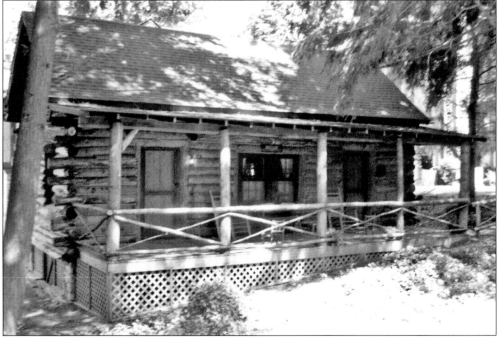

This is a photo of "the cottage" at Teneriffe. It is thought to predate the main house and may have been built c. 1850. The log house was the home of the estate's butler and his family. It is now used as a guest house. (Courtesy Helen and Marvin Seibold.)

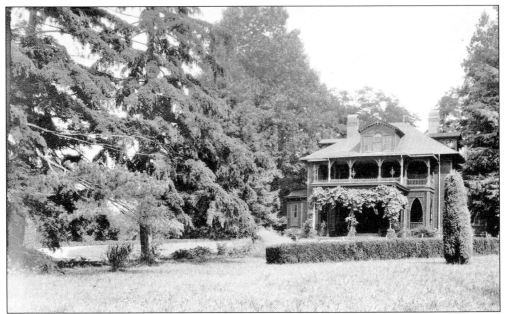

Built by James Pringle, a descendant of early Charleston land proprietor Robert Pringle, Many Pines, *c.* 1847, is a most unique estate. Included in the estate—in addition to the latticed house and long, pine-lined driveway—is a large group of outbuildings not found intact on many properties of this age. (Courtesy Historic Flat Rock, Inc.)

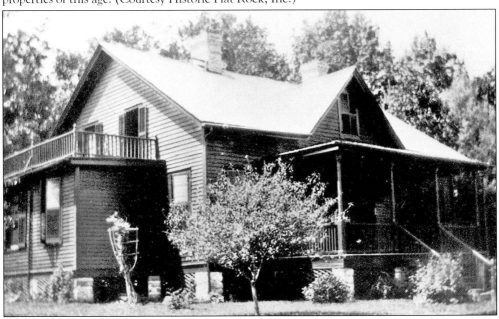

Wigwam, *c.* 1890, was built on land that was once part of the Farmer Hotel tract. It was the summer home of Confederate Civil War general Edward Porter Alexander. The general was 50 years old when he purchased the land. He drew up the plans himself and named the house Wigwam. In the summer of 1902 he began working on his *Military Memoirs of a Confederate* while living at the house. It is now the home of Stephanie and Tom Dunn, who named their son Alexander. (Courtesy Stephanie and Tom Dunn.)

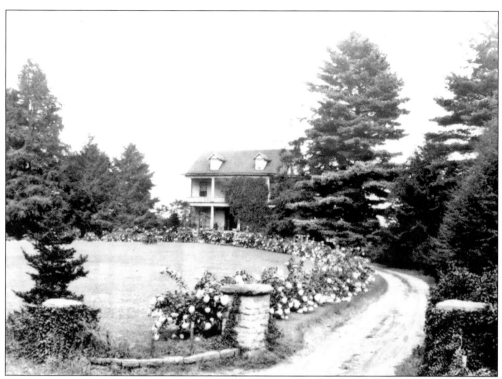

Although no longer standing, Dulce Far Nienti ("sweet nothing to do"), is still talked about today. It was built c. 1836 by Thomas Lowndes of the original Charleston group of settlers. In 1902, Richard I'on Lowndes Jr. purchased Dulce Far Nienti. Built in the Charleston manner with piazzas on each floor, it was an airy and happy place. The land was purchased in 1833, and the circular drive was planted with hydrangeas. The plants bloom faithfully every summer. The property is now owned by Dr. and David S. Hubbell. (Courtesy William P. Andrews.)

This is a photograph of Inez Whitridge Bailey Lowndes, the wife of Richard I'on Lowndes II and grandmother of William P. Andrews. (Courtesy William P. Andrews.)

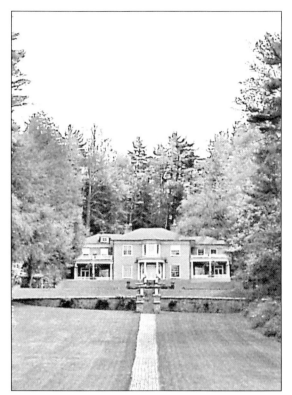

This is a photograph of Chanteloup, originally called the Castle. It was built c. 1841 by the Count and Countess Joseph de Choiseul. The count was the French consul to Charleston and Savannah. The original house was the central portion and was built of native granite. It was purchased by the Norton sisters of Louisville, Kentucky, around 1897. They employed Richard Sharp Smith to design wings on either side, and Frederick Law Olmsted to redesign the gardens and landscape. (Both gentlemen were overseeing the construction of the Biltmore House in Asheville at the time.) Olmsted transformed the grounds into a Blue Ridge version of an Italian Renaissance–style terrace garden. After a period of decline, the property has recently undergone extensive renovation under the ownership of Mr. and Mrs. Leonard Oliphant. (Courtesy Linda and Leonard Oliphant; photo by Sara Bowers Bowen.)

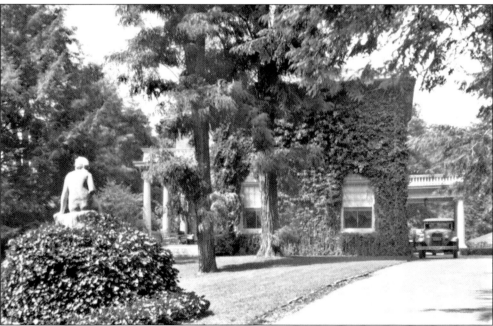

This is a view of Chanteloup from the side, c. 1945. At one time Chanteloup was considered as a site for the North Carolina Botanical Gardens. The house and grounds are spectacular. The house has 12 fireplaces, a flying staircase, and 12- to 14-foot ceilings. (Courtesy Historic Flat Rock, Inc.)

Rutledge Cottage, a charming house in a thick grove of hemlocks, is seen in a recent photo. Built c. 1840 by Dr. Mitchell King as his summer home while he was working in Charleston, it was occupied by him and his family full time while he built his permanent home, Glenroy. When Glenroy was completed, the Cottage was put on logs and rolled about a half mile to its present site. It is thought that the kitchen house, now the guest house, was built prior to the main house. In c. 1857 the house was acquired by Elizabeth and Sarah Rutledge, who were descendants of Andrew Rutledge, a 1740 settler in Charleston, and of John Rutledge, Revolutionary War governor of South Carolina. Sarah Rutledge married Charles Cotesworth Pinckney, great-grandson of Eliza Lucas Pinckney, who introduced the cultivation of indigo. (Courtesy Historic Flat Rock, Inc.; photo by Sara Bowers Bowen.)

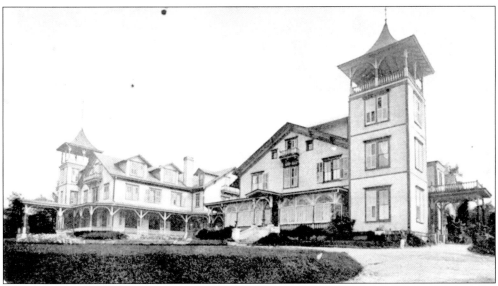

Built c. 1886 by Dr. Arthur Guerard from Charleston, of French Huguenot and German ancestry, Heidelburg House commands a view of Highland Lake and is a most imposing and interesting house. It was designed in the style of his wife's home in Germany. The grounds were planted with linden trees, balsams, and cherry trees, also imported from Germany. For many years it was a gathering place for friends and family, but with the onset of World War I and ill health, the house was sold. It was purchased c. 1921 by the Associate Reformed Presbyterian Church. It is now a conference center known as Bonclarken. (Courtesy Charles Kuykendall.)

Caroline Lowndes Mullally had Boxwood built *c.* 1920. Her husband and her father passed away four months apart, but she wanted this house so much, she went ahead with the construction. This picture shows Mrs. Mullally on horseback in front of the house, where she had 500 boxwoods planted, hence the name. The property is now owned by Mr. and Mrs. Clifton Shipman. Mr. Shipman is a successful local businessman who is known for his restaurant and catering business, Featuring the Cedars. (Courtesy Mrs. Clifton Shipman.)

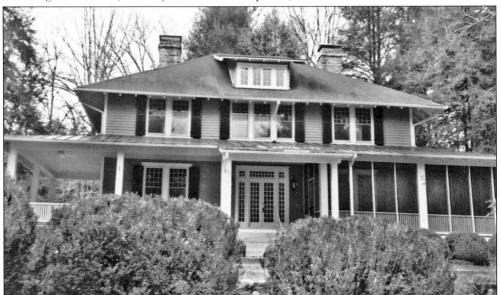

The Dam House, *c.* 1893, formerly known as Greenwoods, was built as a wedding present for Harriet Rhett and Dr. Joseph Maybank. It has a lovely view of Highland Lake and sits just above the dam. The Rhett family owned Highland Lake, which was referred to as Rhett's Pond, at the time this house was built. The house was recently returned to Maybank family ownership when purchased by Joseph and Virginia Maybank. (Courtesy Joseph and Virginia Maybank.)

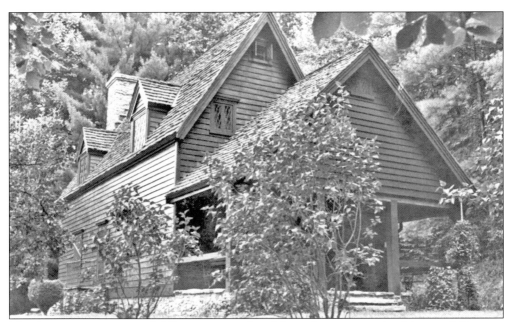

This house was constructed following every detail from the prints in the Library of Congress for the Stone Ender House (*c.* 1680) in Johnston, Rhode Island. The timbers in this structure were collected over a 20-year period and came from early Charleston buildings that had been demolished prior to the present zoning restrictions. Some of the largest timbers came from the Federal Arsenal, which was on Ashley Avenue in Charleston. This home was built by Jack Krawcheck of Charleston. (Courtesy Historic Flat Rock, Inc.)

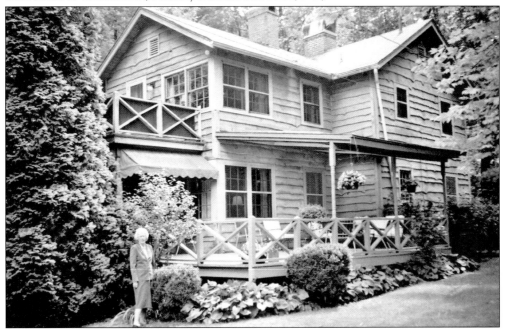

This is a photo of Road's End, *c.* 1928, built as the mother-in-law house to Wigwam. It was owned by Walter B. and Lucile Gillican. This photograph shows the Gillicans's daughter, Lucile (Mrs. Quealy Walker), in front of this charming summer house. (Courtesy Sally Walker Hughes.)

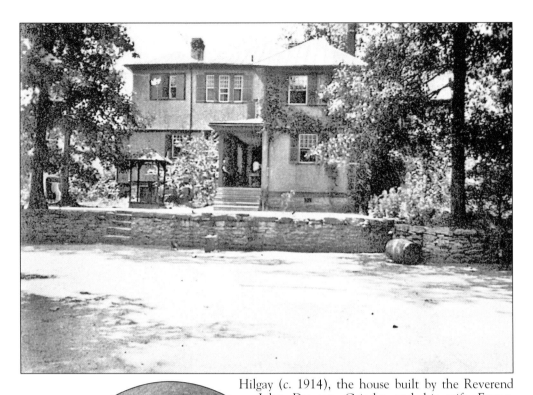

Hilgay (c. 1914), the house built by the Reverend John Drayton Grimke and his wife Emma, sits high on a hill with a view of Glassy Mountain. Emma Grimke was an avowed botanist who planted extensive gardens and unusual trees. Hilgay is currently being restored by Mr. and Mrs. John McCandless. (Courtesy Warren Roberts III.)

This painting shows the Reverend John Drayton Grimke. The Reverend Grimke was the rector of St. Michael's Episcopal Church in Charleston, and he and his wife Emma were the builders of Hilgay. The Reverend Grimke's first parish was in Hilgay, England. (Courtesy Warren Roberts III.)

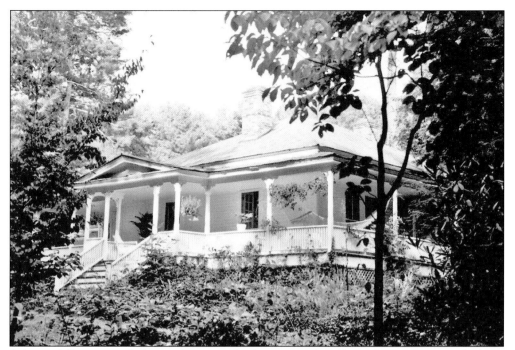

A beautifully preserved Flat Rock cottage, built c. 1890, the Ellen Allston Cottage is built on land that once was part of the Mountain Lodge tract. (Courtesy Carol Faust.)

Here is a photograph of the wonderful wrap-around porch at the Ellen Allston Cottage. The present owner, an artist and antique dealer, has successfully retained the 19th-century feeling and look of the property. (Courtesy Carol Faust.)

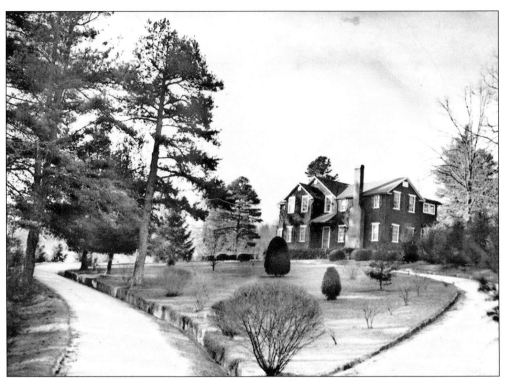

Built on land that was purchased many years earlier, The Little Hill, built *c.* 1934, is the home of Dr. John Laurens II. The Laurens family is prominent in American history. Dr. Laurens II is a direct descendant of Henry Laurens, owner of Mepkin Plantation in Charleston, which is now Mepkin Abbey. Henry Laurens was president of the Third Continental Congress, and he was elected to the State Legislature, to Congress, and to the Federal Constitutional Convention of 1787. He also spent more than four years abroad on behalf of the American cause, including 15 months in the Tower of London. Dr. John Laurens II makes The Little Hill his permanent home. (Courtesy Dr. John Laurens II.)

Pictured here is the south end of the driveway to Tall Trees. It is a typical and very pretty example of the drives leading to Flat Rock's historic homes.

Two

CHURCHES
and CHURCHYARDS

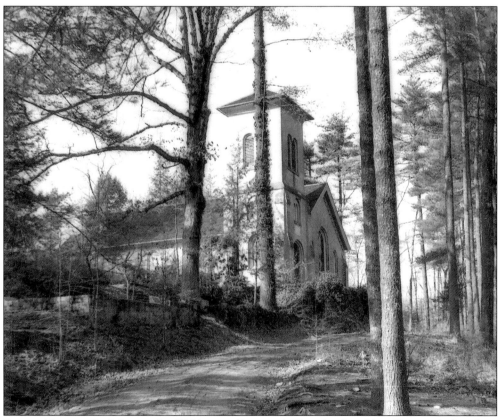

Pictured here is St. John in the Wilderness Episcopal Church, the oldest Episcopal church in Western North Carolina. Originally built as a private chapel by Charles and Susan Baring, the original wood building burned and was rebuilt on the present site. The church was consecrated in 1836. In 1852, because of a growing congregation, the church was doubled in size. St. John in the Wilderness is a central focus of the village. (Courtesy Historic Flat Rock, Inc.)

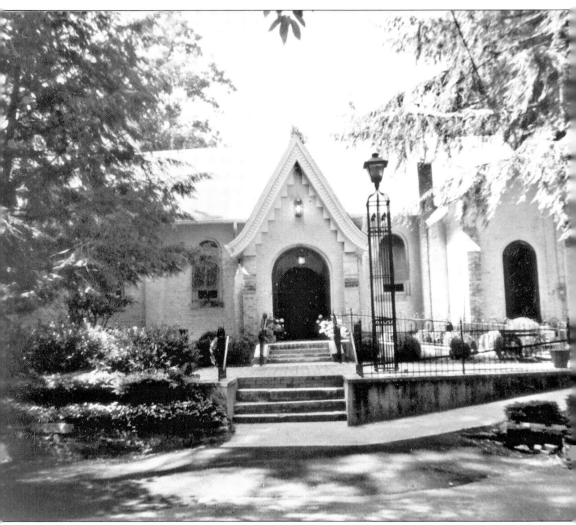

This is the carriage entrance to St. John in the Wilderness Church. It has been written that the service could not begin until Susan Baring arrived and entered the church from her carriage. To the left of the entrance is the grave of James Brown of Glasgow, Scotland, a trumpeter with the Scot's Grays at the Battle of Waterloo, and his wife, Agnes. They came to Flat Rock with the Barings and were among the original organizers of St. John in the Wilderness Church. The earthly remains of Charles and Susan Baring, builders of St. John in the Wilderness, lie within the south wall of the church.

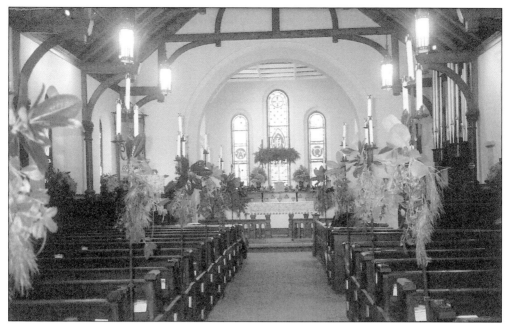

A recent photo of the interior of St. John in the Wilderness Church shows the church decorated for Christmas. The architect was Edward James of Charleston. The altar is a Holy Table believed to have come from England, and the ceiling beams were cut from southern short-leaf pine. The pews are square in the English style and still bear the nameplates of pew holders.

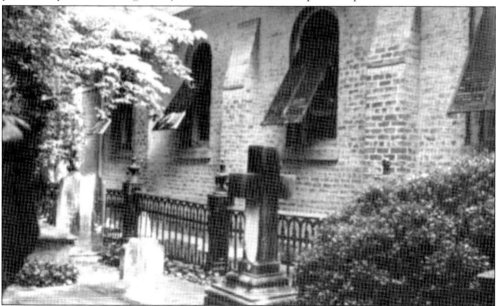

The churchyard surrounding St. John in the Wilderness Church tells the story of Flat Rock's past. In addition to the graves of Southern gentry, it contains graves of men who were of much importance in the formation of our country. Among them you will find the names of the families of three signers of the Declaration of Independence (Heyward, Middleton, and Rutledge) and of Christopher Gustavus Memminger, the first secretary of the treasury of the Confederate States.

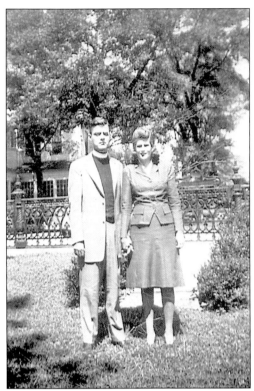

This is a *c.* 1948 photograph of the Reverend Walter Douglas Roberts and his wife, Zelda Drayton Grimke. He was the first priest to become full-time rector at St. John in the Wilderness Church. (Courtesy Warren Roberts III.)

This is a recent photograph of the Drayton family plot. The Reverend John Grimke Drayton, longtime rector of St. John in the Wilderness Church, created and planted Magnolia Gardens in Charleston. From his Flat Rock home Ravenswood, he created a path through the woods to the church. The path went through several properties and was called the Jerusalem Path. For a time it was mentioned in property deeds, but it has now been closed and is grown over. This path was for the use of those who wished to walk to church on Sunday, so their servants and animals could rest on Sunday.

Pictured here is the grave of Lt. Col. Charles de Choiseul, CSA. He was the son of the Count and Countess de Choiseul, who were early settlers in Flat Rock and built Saluda Cottages and Chanteloup. Charles became a citizen in 1840 and was a surveyor of Henderson County. He entered the service in the Confederate States Army in 1861 and was sent to Virginia. He was killed in 1862 near Port Republic, Virginia. His body was brought back to Flat Rock to be buried in the family plot next to his mother and sisters.

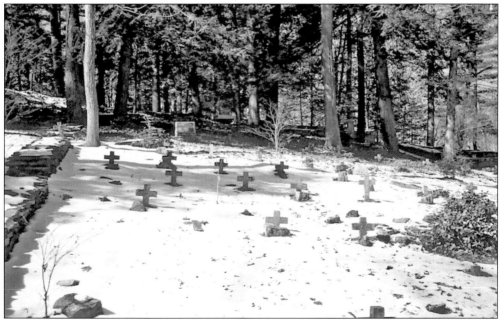

On a wooded slope in front of St. John in the Wilderness Church, prior to emancipation, land was set aside for slaves and their families who worshiped at the church. Until 1970 graves were marked with plain stones. Clyde Blaedorn made small cement crosses for each grave and they were given by the congregation. Thirty-six graves were found, but there may be more. Several servants were buried here after emancipation as well.

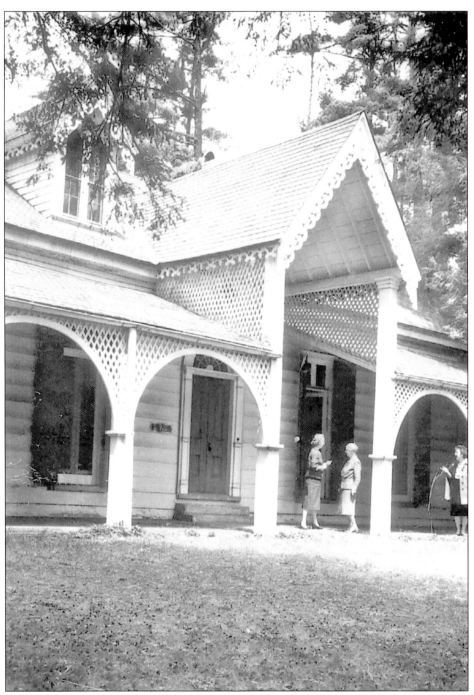

Built as a private parsonage for St. John in the Wilderness, Diamond in the Desert, c. 1834, served as the home for the Reverend S.W. Mott, who was brought to Flat Rock from Oxford, England, to be rector at the church. Reverend Mott also ran a school for young children of the community at the house. It was purchased by Richard Lowndes c. 1846. The house burned in 1960. Its location was just to the north of the Flat Rock Playhouse on the Greenville Highway. (Courtesy Lowndes and Burke families.)

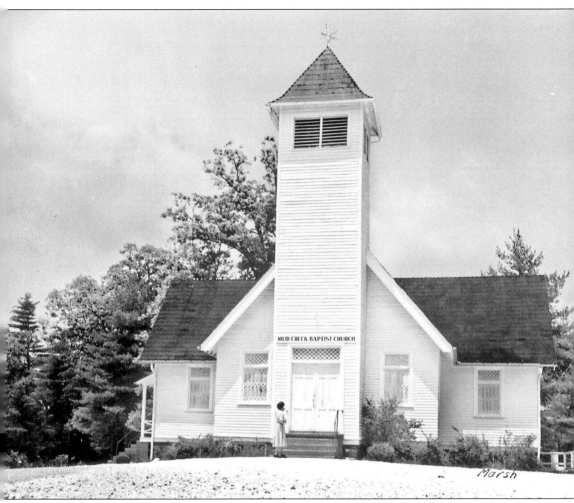

The Mud Creek Church, known at the time of its founding as the Mud Creek Meeting House, was organized sometime between 1802 and 1804. The original congregation occupied a public meeting house on land owned by Abraham and Elizabeth Kuykendall. Records show that Abraham Kuykendall, an early settler, registered the first request for a land grant after the Revolutionary War. The original meeting house stood along Old State Road, in what is now the cemetery. The original building was torn down c. 1850 and a log church was built at that time in the vicinity of the original building. The church building shown was built in 1900 and stood across from the cemetery on what is now Erkwood Drive. It served the congregation until 1964. The Mud Creek Baptist Church now serves a congregation of over 2,600 members.

Pastor Blythe from the Mud Creek Baptist Church is shown calling on unidentified parishioners, c. 1950. (Courtesy Barbara Lohman.)

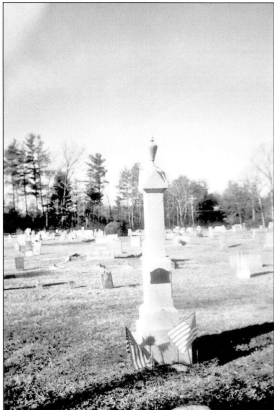

This is a recent photo of the Mud Creek Historic Cemetery showing the grave and monument of Capt. Abraham Kuykendall, a hero of the American Revolution. This is the oldest documented grave in the cemetery. Kuykendall was buried in 1812 on land he donated to the Mud Creek Church. Legend has it that at the time of his burial, large trees were cut, split in half, and used to reinforce his grave to protect it from ravaging animals. In all likelihood there are even older graves than Captain Kuykendall's, as his wife Elizabeth died in 1803 and is most likely buried next to the old patriot. The cemetery contains the graves of veterans of almost every war in which the United States has been involved. (Courtesy Charles Kuykendall.)

Three

WAR STORIES

Shown here are descendants of Abraham Kuykendall, whose family lived in the Dutch-settled Hudson Valley of New York since the 1640s. In the years preceding and during the American Revolution, Kuykendall served North Carolina valiantly—as a member of Samuel Adams's Committee of Correspondence, considered to be the cadre of the American Revolution; beginning in 1775, as a captain of a safety committee that governed Old Tryon County; as a captain in the North Carolina Militia from 1770 to 1783; and as justice of the Court of Pleas and Quarter Sessions and justice of the peace for the area that eventually became Rutherford County. On October 10, 1779, several years before the area was open for settlement, he entered a request for a land grant in the current vicinity of Mud Creek Church. Around 1790, while over 70 years old, Captain Kuykendall moved to Flat Rock along with his family and servants. He went on to acquire extensive acreage and started some of Henderson County's earliest businesses, including an inn, a tavern, and a mill. Pictured here are Jacob Rollo and Henrietta Thompson Kuykendall of Flat Rock. Jacob Rollo fought for the Confederacy and was wounded in the battles of Petersburg, Virginia, and at Plymouth, North Carolina. (Courtesy Charles Kuykendall.)

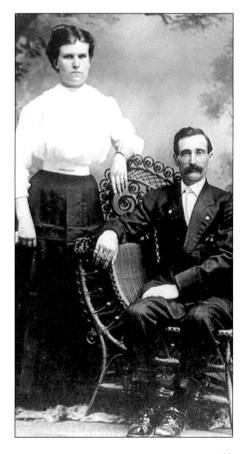

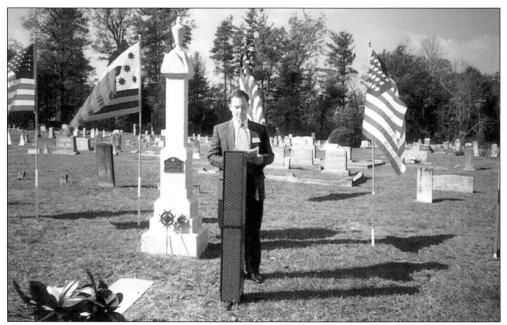

Pictured here is the October 2000 ceremony honoring Revolutionary War patriot Capt. Abraham Kuykendall, sponsored by members of the Abraham Kuykendall Chapter of the Daughters of the American Revolution and members of the Kuykendall family. Charles Kuykendall gave the address. (Courtesy Charles Kuykendall.)

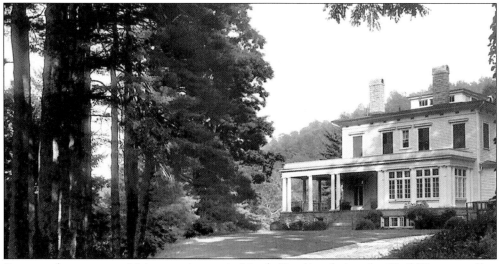

Because of some strong Union sentiments in North Carolina during the Civil War, as well as the density of the Blue Ridge Mountains, Flat Rock became a haven for deserters from both sides. These lawless bands were called bushwackers or renegades. They lived in the mountains and pillaged homes. Although Glenroy was almost a mile off the road, it did not escape invasion by bushwackers. Legend has it that sterling silver and other valuable items were taken from the house, wrapped in bags, and hauled off into the mountains. A faithful black servant was also taken to carry the goods. When the thieves slept after a night of celebration, the servant crept off, taking the valuables with him. After spending the night in hiding, he returned all the property safely to the mansion. (Courtesy Historic Flat Rock, Inc.)

Brig. Gen. Edward Porter Alexander graduated West Point in 1857. In 1861 he entered the Confederate Army, and in 1862 he was made a colonel and was with Longstreet at the battle of Gettysburg. He was promoted to brigadier general of artillery in 1864. Among his many accomplishments, he was the general manager and president of several railroads. He and his wife, Bettie Mason, built their house in Flat Rock, following plans he drew himself. Wigwam was their summer home, and here he began working on his memoirs, *Military Memoirs of a Confederate*. Courtesy *The Twentieth Century Biographical Dictionary of Notable Americans*, *Vol.X*. Rossiter Johnson, ed. Boston.)

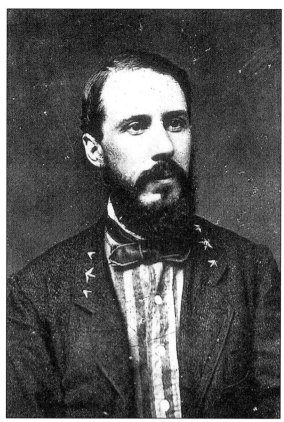

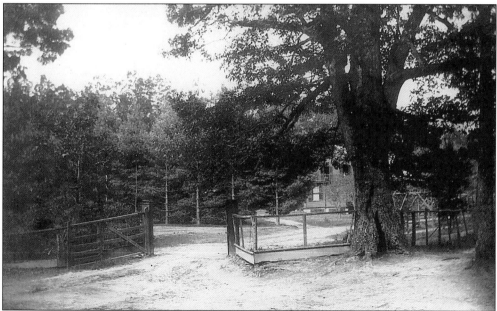

Pictured here is a view of the entrance to Wigwam, the summer home of Edward Porter Alexander. A portion of the road that is now the Greenville Highway can also be seen. (Courtesy Mr. and Mrs. Thomas P. Dunn Sr.)

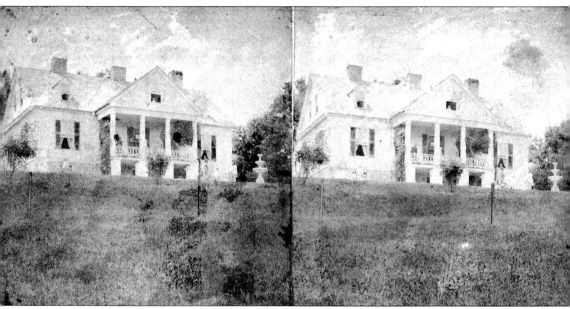

This is a stereopticon of Rock Hill, the home built by Christopher Gustavus Memminger, where he lived with his family. During the Civil War years, many prominent South Carolina families took refuge in Flat Rock, staying at the Farmer Hotel (the Woodfield Inn), and often they came to Rock Hill looking for protection. Memminger fortified his house against invasion and frequently hosted many friends and neighbors who felt threatened. Memminger suggested to President Jefferson Davis that he move the capital to Flat Rock and Rock Hill. It was seriously considered but rejected because of inaccessibility and isolation. (Courtesy Carl Sandburg Home NHS National Parks Service [NPS].)

Seen in this old photograph of Enchantment is Mary Middleton Pinckney Lee, niece of Dr. Allard Memminger and wife of Confederate general Robert E. Lee's grandson. Mrs. Lee made Enchantment her home for many years and was known for her grand parties. She was the former Mary Middleton Pinckney of Charleston. Her husband, Robert E. Lee III, was the son of W. Fitzhugh and Mary Tabb Bolling Lee and was educated in law. He was a colonel and aide de camp of Governor Montague of Virginia. Colonel Lee died in 1922 and was buried in the Lee Chapel Mausoleum in Virginia. Mrs. Lee had her husband's remains removed from Virginia and reburied c. 1938 in Charleston, where they share a burial site. (Courtesy Mary and MacDonnell Tyre.)

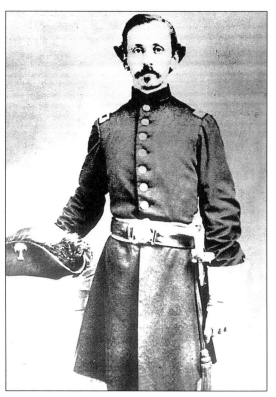

This is an early photo of Maj. Theodore Gaillard Barker in his dress uniform. He was the owner of Brooklands. (Courtesy Mr. and Mrs. Gene Staton.)

Pictured here is Major Barker riding in a carriage, sitting on the right of Gen. Wade Hampton, at the 1899 Confederate Reunion in Charleston. (Courtesy Mr. and Mrs. Gene Staton.)

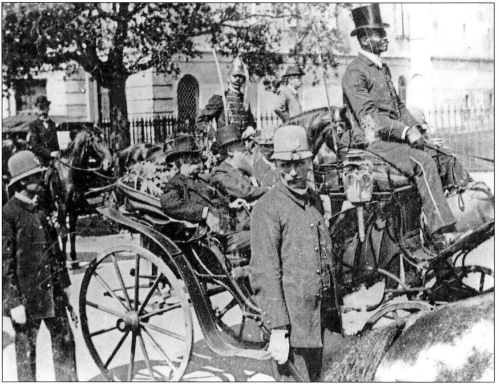

Although this photo is of very poor quality, it is one of the very few photos taken of Charles de Choiseul, son of Count and Countess de Choiseul. He was said to have fought bravely in the first Battle of Bull Run. In 1862 he died while fighting near Port Republic in Virginia. He is buried at St. John in the Wilderness, and the flag of France, his native country, stands in the Tower Room of the church in his memory. (Courtesy Danny Ogletree.)

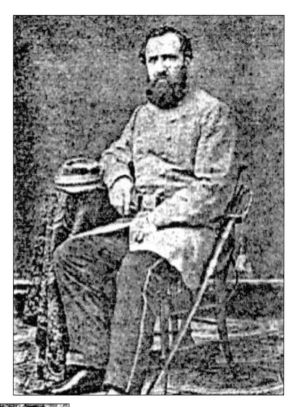

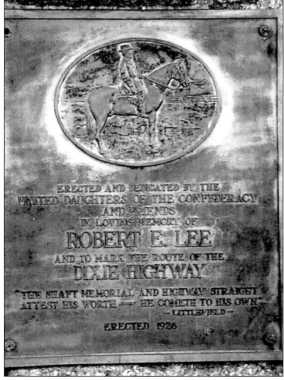

This plaque, affixed to a monument at the Old Henderson County Courthouse, reads: "Erected and dedicated by the United Daughters of the Confederacy and friends in loving memory of Robert E. Lee and to mark the route of the Dixie Highway. 'The Shaft Memorial and Highway straight attest his worth—he cometh on his own.' Littlefield. Erected in 1926." Also at the courthouse stands the Civil War monument. Once located in the center of the street, it is now on the lawn of the Old Courthouse.

Owned by Andrew Johnstone, beautiful Beaumont was the scene of the area's worst wartime tragedy. Bushwackers posing as Confederate soldiers barged into the house where Johnstone and his family were dining. After Johnstone graciously fed the intruders, they turned ugly and shot their host, killing him. Johnstone's son Elliott tried valiantly to avenge his father's death and succeeded in shooting at least one of the bushwackers, but the others got away. (Courtesy Mrs. Elizabeth R. McCoy.)

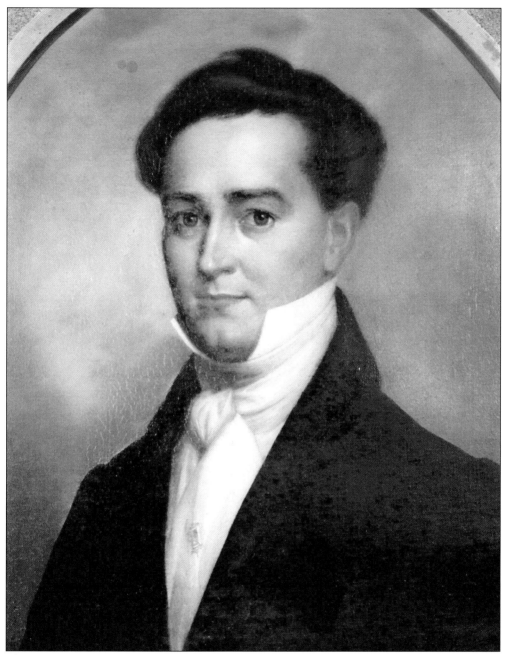

This photograph shows a painting of Andrew Johnstone, owner of Beaumont, killed by bushwackers in his own home. Together with C.G. Memminger, he opened Little River Road. (Courtesy Mrs. Elizabeth R. McCoy.)

The family of Lt. Col. David Urquhart, CSA, owned The Castle (Chanteloup) for a period of years during the Civil War, having purchased it c. 1858. Because of the hardships brought about by the war, they were unable to keep up payments on the property, and it was returned to the de Choiseul heir c. 1875. (Courtesy Danny Ogletree and Henry Urquhart.)

In one of the most detailed Civil War stories of local interest, we learn of the plight of John V. Hadley and his companions of the 7th Indiana Infantry. *Seven Months a Prisoner*, written by Hadley, tells of their harrowing escape from prison camp and their journey through Flat Rock in their effort to get back to Union headquarters in Tennessee. After being helped by sympathizers along the way, they hid on snow-covered Glassy Mountain in Flat Rock until starvation took them to a frozen cabbage patch belonging to the Hollingsworth family on the grounds of Tranquility. Here they were rescued by five sisters who assisted them in finding a guide and who gave them food and shelter. This is a recent photo of Tranquility.

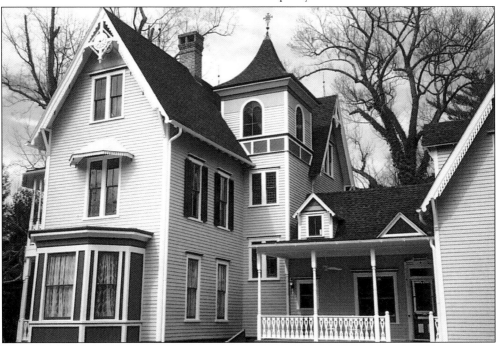

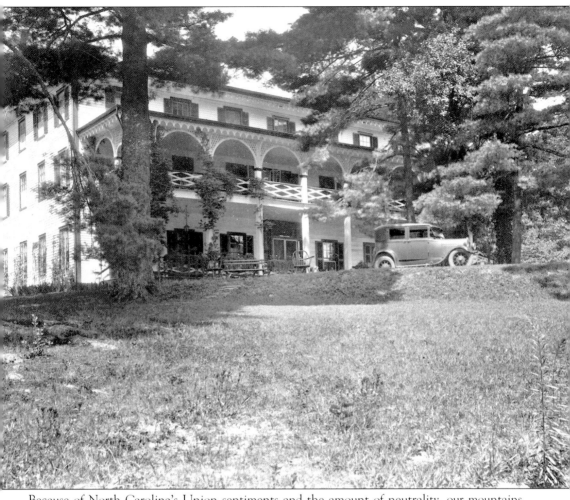

Because of North Carolina's Union sentiments and the amount of neutrality, our mountains became a haven for deserters. It was such a problem that the Confederacy formed an independent Department of Western North Carolina, out of Asheville. It was headed by Capt. B.T. Morris and the E Company 64th North Carolina Regiment. Their duty was to break up bands of robbers as well as protect families and their valuables. These troops were concerned with the protection of life and property from roving bands. In 1864 this company camped on the lawn of the Farmer Hotel, now the Woodfield Inn. (Courtesy Historic Flat Rock, Inc.)

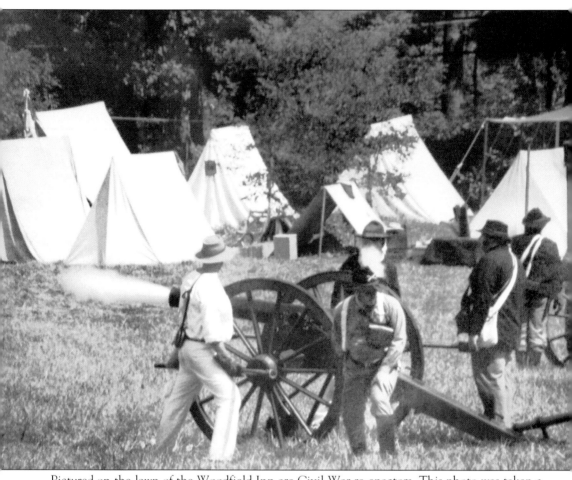

Pictured on the lawn of the Woodfield Inn are Civil War re-enactors. This photo was taken c. 1997. (Courtesy Pete Zamplas.)

Pictured just after the battle of "Cantigny," June 1918, are, from left to right, Col. Campbell King of Flat Rock; Gen. John L. Hines, chief of staff First Division (seated); and Col. George Marshall at Beauvais. (Courtesy Danny Ogletree.)

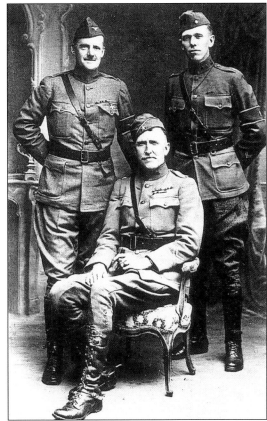

Pictured here are members of the Military Intelligence Group, Lt. Col. Ralph Vernon (left), Captain Berry (center), and Flat Rock's Lt. Alexander C. King, a member of the 519th Battalion and the Group Language Training section during the Korean War. (Courtesy Alec C. King.)

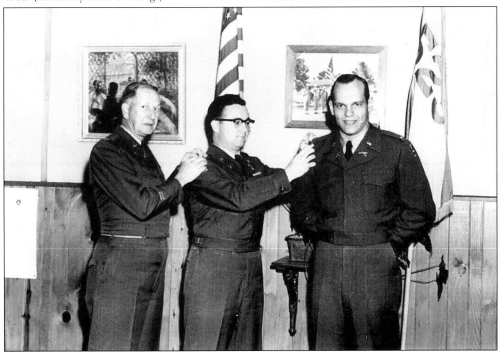

53

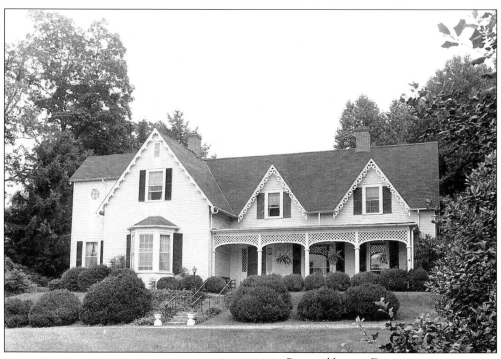

Pictured here is Dunroy, an estate purchased in 1933 by Maj. Gen. Campbell King, grandson of Judge Mitchell King, the early settler who built Argyle. In World War II George C. Marshall was in Major General King's command. After the war he formed and commanded the infantry training school of Fort Benning, Georgia. During World War II General Marshall visited Dunroy. (Courtesy Historic Flat Rock, Inc.)

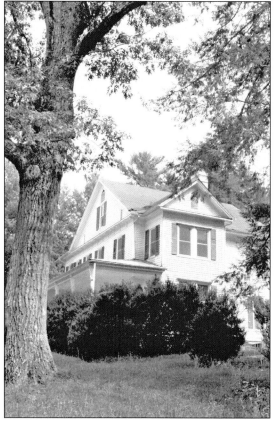

Pinecrest was built by Lt. Col. Charles Simonton, the 13th commander of the Washington Light Infantry (WLI). In 1862 he was promoted to colonel of the 25th Infantry, detached from the WLI and placed in command of James Island, South Carolina. Later in life he served as U.S. district judge. In 1860 a medal was struck in his honor, and in November 1999 it was reissued as the Medal of the Month in honor of the WLI and Judge Simonton.

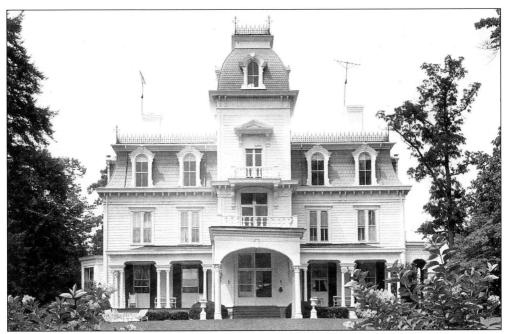

Lt. Rudolph Siegling was attached to Bachman's battery of the German Light Artillery in Maryland in September 1862. He was seriously wounded. The shell was retrieved by his close friend and future law partner, James Simons, and given to his family with the report of his probable demise. After being wounded he told the others to leave him and he fashioned a makeshift shelter. He was found by his father, who brought him home to recover, after which Siegling finished fighting the war. After the war he published the Charleston *News and Courier* and purchased Saluda Cottages, changing the name to San Souci. (Courtesy Mrs. Effie Bowers.)

Pictured here is the Old Stone Spring at the Farmer Hotel. It is thought this spring was a gathering place for the Confederate soldiers who were posted at the hotel to provide protection for Flat Rock residents. It became a gathering spot for picnickers in later years. (Courtesy John Laurens III.)

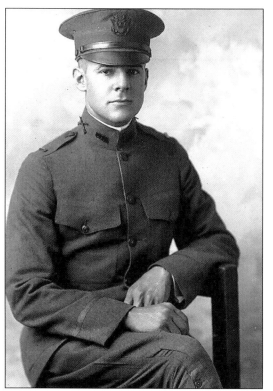

William P. Andrews Sr. is seen *c.* 1917 in his World War I uniform. Andrews attended Davidson College and left to go into the army. He trained at Plattsburg, New York. After World War I he went to college at the University of North Carolina Chapel Hill, where he roomed with Thomas Wolfe, noted author from Asheville, North Carolina. (Courtesy William P. Andrews.)

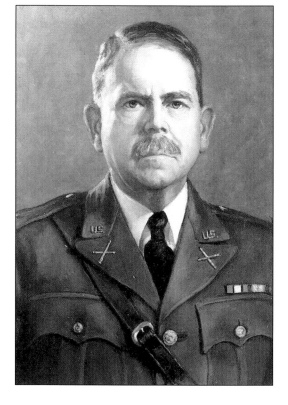

Gen. Edward Postell King, descendant of Judge Mitchell King, was left in command of American troops when General MacArthur and General Wainwright were able to escape Corrigador. General King led the troops on the heroic "Death March of Bataan." He is buried at St. John in the Wilderness Cemetery. (Courtesy Danny Ogletree.)

Four

Transportation
and Enterprise

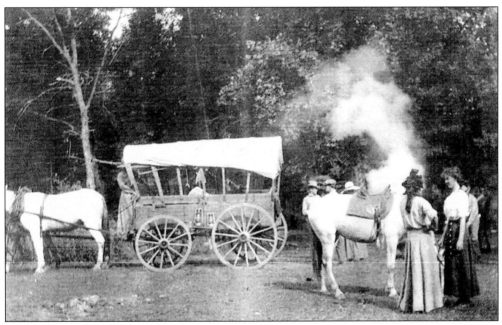

This unidentified group of travelers is possibly on a journey from Charleston to Flat Rock, a two-week trip that included the twisting, curving mountain road through the Saluda Gap known as the "Winding Stairs." (Courtesy Marty Whaley Cornwell.)

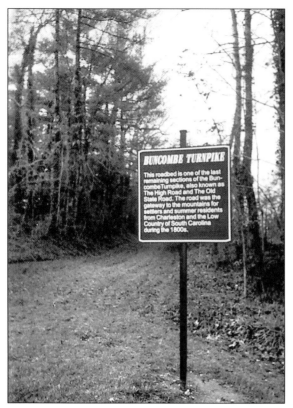

These are recent photographs of the last remaining portion of the Saluda Wagon Road in its original form. This section of the road lies to the southwest of the Mud Creek Cemetery and can be accessed through the Dunroy subdivision. This road was the first public road in what is now Henderson County. It was created prior to 1793 and entered Flat Rock via Mine Gap Road, followed the current Greenville Highway, and swung northwest on what is now Rutledge Drive. It continued across Mud Creek around the present location of the bridge on Erkwood Drive and then went on its way north to Asheville. (Courtesy Charles Kuykendall.)

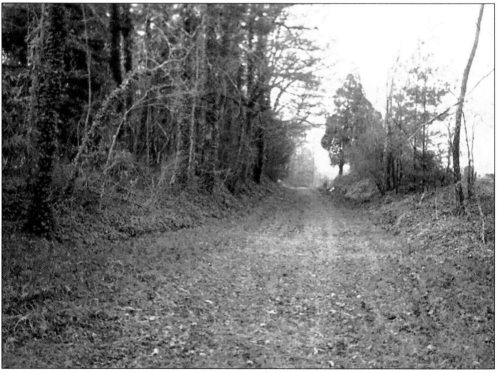

Here we have a photo of an unidentified gentleman out on a carriage ride on a chilly day. This photo may have been taken on the grounds of the Brookland Manor. (Courtesy Mr. and Mrs. Gene Staton.)

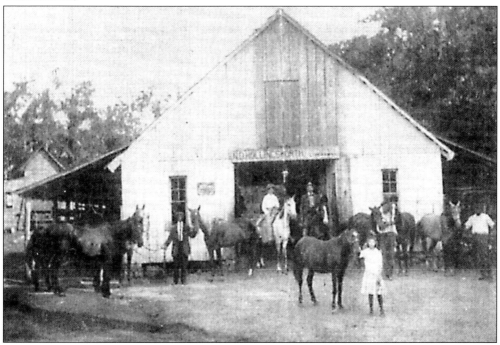

This is a very old photograph of Hollingsworth's Livery Stable in Flat Rock. Horses and their care were an important part of life in Flat Rock for very many years. (Courtesy Lewis King.)

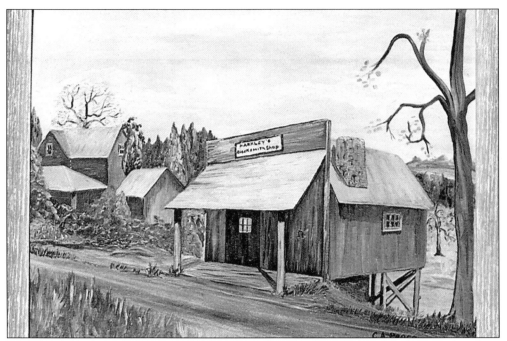

Markley Blacksmith Shop is the subject of an oil painting by Clarence A. Peace. This shop, which stood along present-day Blue Ridge Road, was operated for many years by John Markley and his son James R. Markley. (Courtesy Sally Walker Hughes.)

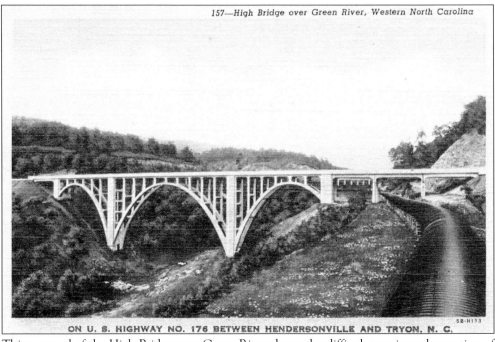

This postcard of the High Bridge over Green River shows the difficult terrain and a portion of Highway 176 between Flat Rock and Tryon. (Courtesy Charles Kuykendall.)

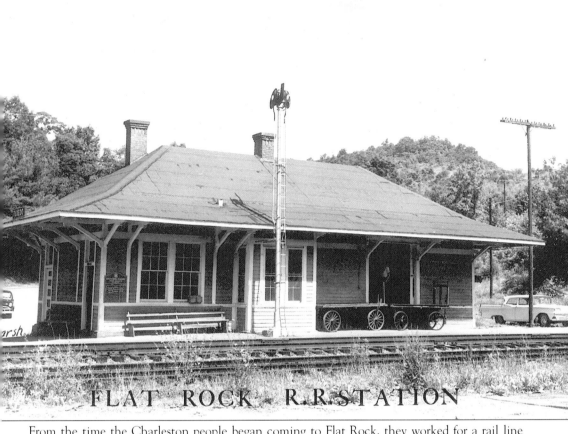

FLAT ROCK R.R. STATION

From the time the Charleston people began coming to Flat Rock, they worked for a rail line from Charleston to the inland waterway to the west. C.R. Memminger and Judge Mitchell King worked tirelessly to get the line built. Memminger served as the first president of the Spartanburg and Asheville Railroad. On July 4, 1879, rail service officially opened between Spartanburg and Hendersonville. The difficult installation of tracks up Saluda Grade (5.3 percent grade), the steepest grade in the country, east of the Rockies, was worthwhile. The railroad opened floodgates for people and commerce. It had a profound effect on the farming community as now produce and livestock could be shipped by rail rather than by wagons and droves. It opened the area for more tourism than ever before. The railroad station in east Flat Rock was a small log station house. Pictured here is the station that was built in 1889, which was demolished when train service stopped in 1958. (Courtesy Historic Flat Rock, Inc.)

This is a photograph of the Old Mill on the edge of Highland Lake. It would later serve as the first location for the Flat Rock Playhouse. (Courtesy Betty Lee.)

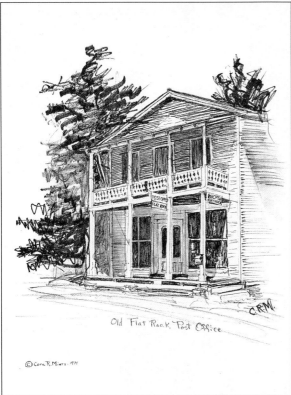

Old Flat Rock Post Office

© Cora R. Minty 1971

The Old Post Office building is located in the center of Flat Rock. In addition to being a post office, there was a store in the building for some time run by James Ripley. At this time the postmaster was Mathew Singleton Farmer. He hired a mail messenger when mail started to arrive by rail, and the first messenger was blacksmith Markley. During the War Between the States a group of armed citizens were posted at the building in what may have been the first neighborhood watch. This is a Cora R. Minty print, 1971. (Courtesy Historic Flat Rock, Inc.)

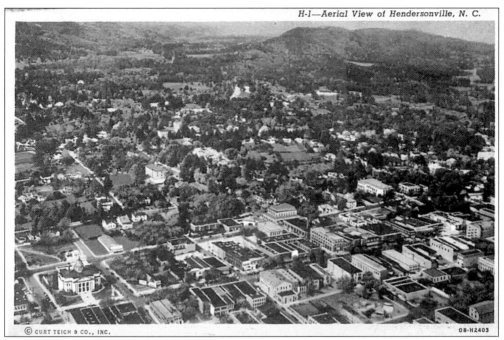

© CURT TEICH & CO., INC. OB-H2403

Here is a postcard showing an aerial view of Hendersonville. In the lower left can be seen the county court house, which was built on a portion of the 50-acre piece of land donated for that purpose by Judge Mitchell King of Flat Rock. The Henderson County seat was laid out in 1841, and the court house was built three years later. (Courtesy Historic Flat Rock, Inc.)

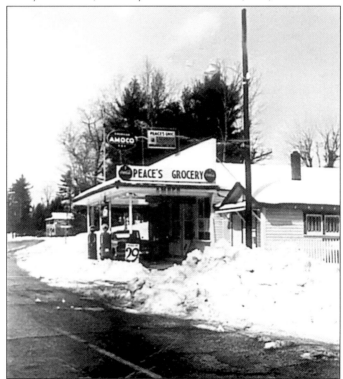

A Peace family Christmas card shows Peace's Store on the corner of the Greenville Highway and Blue Ridge Road. The Old Post Office can be seen in the background. (Courtesy Barbara Peace Lohman.)

63

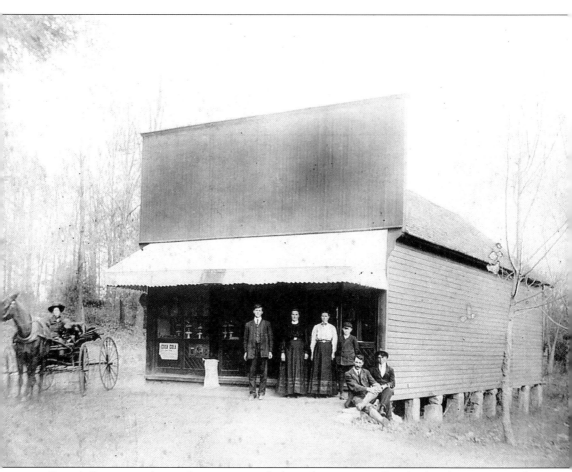

Peace's Store carried everything necessary for housekeeping as well as food. In later years gasoline tanks were added for the new mode of transportation. Standing in front of the store are, from left to right, (standing) J. Luther Peace, Mattie Peace, Martha Peace, and Grover B. Peace; (seated) Milton Peace and his son Hixie. Peace's Store is now The Wrinkled Egg. It is located in the heart of the village on the corner of the Greenville Highway and Blue Ridge Road. (Courtesy Mrs. Barbara Peace Lohman.)

This is a recent photograph of Five Oaks, now the Flat Rock Inn. The house was built c. 1888 as a summer retreat for R. Withers Memminger, a minister from Charleston and the son of Christopher Gustavus Memminger. Five Oaks was bought by Thomas and Elizabeth Grimshawe and inherited by their daughter Greta Grimshawe King and her husband, Campbell King. The inn is now an attractive and well-preserved bed and breakfast owned and operated by Dennis and Sandy Page. (Courtesy Dennis and Sandy Page.)

Here we have an old photograph of Mrs. Elizabeth Grimshawe preparing for a buggy ride, with the help of her man servant in front of her home, Five Oaks. (Courtesy Dennis and Sandy Page.)

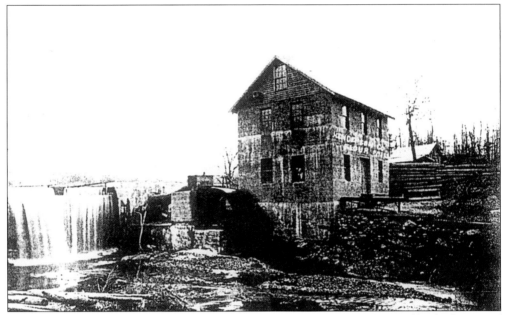

This is a photo of the Old Mill when it was the Henderson County Flour Mill. The history of the Old Mill goes back to a land grant for the property dated December 21, 1830. Peter Summey was the miller and picked this site on Earle's Creek, which flows under Blue Ridge Road. It was an active and busy enterprise, not only a flour mill but a mill for all water-ground products and feed. When the Flat Rock Hotel (Woodfield Inn) was built, Henry T. Farmer purchased the furnishings from J. & J. Hildebran in Asheville. Transportation at that time was difficult, so he set up his own furniture factory in the Old Mill and made tables, chairs, beds, cabinets, sofas, and rockers. The property is now Mill House Lodge, operated by the Horky family. The water wheel and part of the original building are still a part of the lodge. (Courtesy the Horky family.)

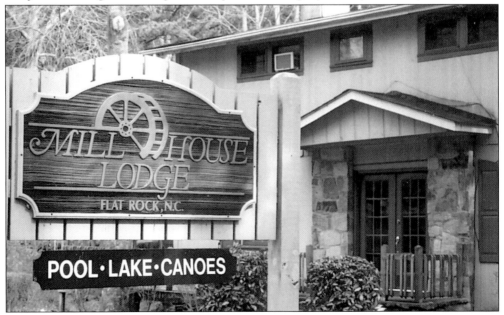

This is a recent photograph of the Mill House Lodge. (Courtesy the Horky family.)

Flat Rock chairs are highly collectible and made of walnut. There are two variations: the most commonly seen have arms with the narrow side up and a circle at the end of the arm, and the other has flat arms, wide enough to hold a glass of ice tea. (Courtesy Debbie and Gene Staton.)

Another recent photograph shows Flat Rock furniture, manufactured by Squire Farmer. The sofa is large and comfortable and one can imagine the old Farmer Hotel being furnished with an abundance of these items. (Courtesy Debbie and Gene Staton.)

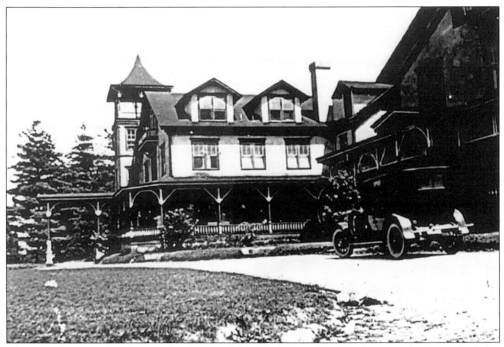

This is a photograph taken in the 1930s of the Heidelberg Hotel. This was the home built by Dr. Arthur Guerard of Charleston on Highland Lake. It was operated as a resort hotel for some years, and in 1922, the property went to the Associate Reformed Presbyterian Church for a conference center and camp. It is host to "REACH," formerly known as Kids Adventure Camp. (Courtesy Bonclarken Conference Center.)

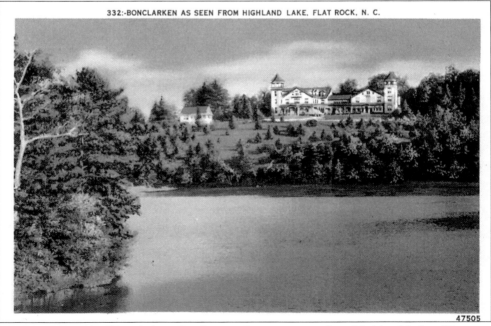

332:-BONCLARKEN AS SEEN FROM HIGHLAND LAKE, FLAT ROCK, N. C.

47505

Here is a postcard of Bonclarken Conference Center as seen from Highland Lake. (Courtesy Charles Kuykendall.)

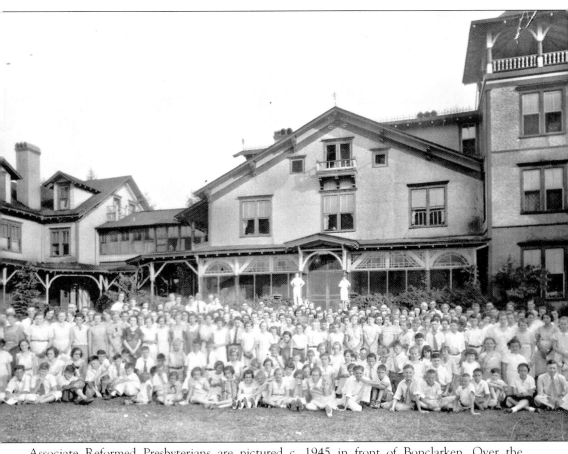

Associate Reformed Presbyterians are pictured c. 1945 in front of Bonclarken. Over the years since the property became Bonclarken, many additions have been made—including athletic facilities, a chapel, and dormitories. (Courtesy Bonclarken Conference Center and Charles Kuykendall.)

Kanuga Conferences began as a private summer resort planned by George Erwin Cullet Stephens of Charlotte, shown here. It is believed that on a trip through Flat Rock, he had time to spare between trains and decided to explore. He found wonderful property with views, lovely trees, and water. He hired John Nolan (city planner) and Richard Sharpe Smith (supervising architect at the Biltmore Estate) to execute his plan. It opened as the Kanuga Lake Club in 1909 and had a 100-acre lake, large rambling inn, 39 cottages, and lakeside pavilion. (Courtesy Kanuga Conferences.)

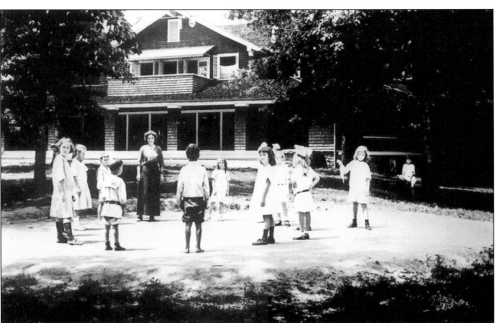

These children are pictured playing a supervised game of "drop the handkerchief" at the Kanuga Lake Club when it was operated as a family resort c. 1910. The original Kanuga Lake Inn is in the background. (Courtesy Kanuga Conferences.)

When there was no longer a calling for the resort, George Stephens was instrumental in its acquisition by the Episcopal Church in 1928. This is a photograph of Bishop Kirkman Finlay, who made Kanuga his summertime ministry from 1928 until his death there in 1938. His house, Perth, still stands in Bonclarken. The bishop was fond of leading hikes. (Courtesy Kanuga Conferences.)

Young campers from Kanuga Conferences are pictured enjoying the view after hiking to High Rocks c. 1950. (Courtesy Kanuga Conferences.)

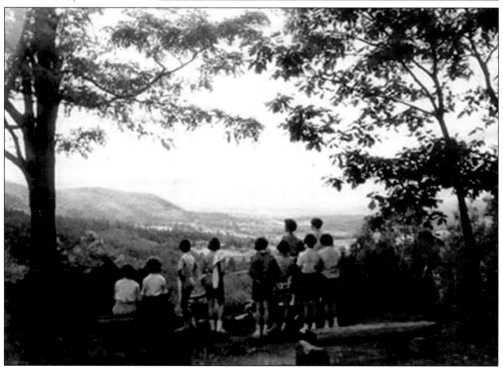

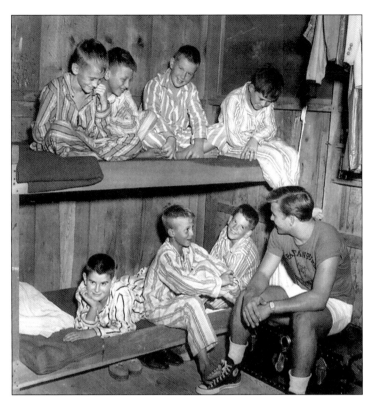

Kanuga Conferences offers summer camps for boys and girls. This cabin bedded down c. 1960. (Courtesy Kanuga Conferences.)

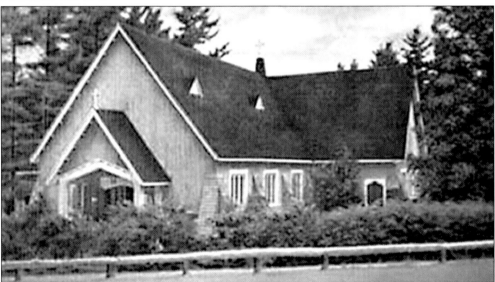

This is a postcard of the Chapel of Transfiguration, built 1940 and dedicated in 1942 at Kanuga Conferences. The chapel, the traditional cottages, and St. Francis Chapel are on the National Register of Historic Places. The conference center has become one of the great Christian conference centers in Western North Carolina. It operates 12 months a year and offers camping for boys and girls, as well as full conference facilities. Its service extends internationally and for 10 days it hosts the annual meeting for Anglican Primates, making Kanuga the center of the Anglican community. (Courtesy Kanuga Conferences.)

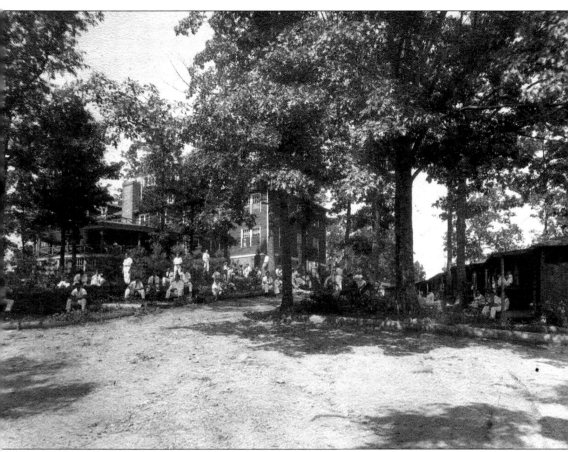

The land on which Highland Lake Club and Conference Center is located was a part of the original land grant to John Earle, who established the first grist mill on the property. Charles Baring, who built Mountain Lodge, constructed a house on a hill with a view of the lake and called it Solitude. The house was sold to George Trenholm (second secretary of the Confederate Treasury) and then c. 1873 to William Aiken, governor of South Carolina. When Governor Aiken died, the house went to his daughter, Mrs. A. Burnet Rhett. The mill was renamed Rhett's Mill, and the lake was known as Rhett's Pond. Also summering at Highland Lake were Gov. Burnet Maybank and his son Lt. Gov. Burnet Maybank, who still has a house here. Gov. Strom Thurmond also frequented the area. Solitude burned down and subsequently a large hotel was built c. 1910, along with an 18-hole golf course. The course was built by Joseph Holt and was the first in Western North Carolina. The name was Highland Lake Club. The club was short lived, however, and it became Highland Lake Boys' Camp, Camp Brandeis, and Our Lady of the Hills Camp. The Highland Lake Inn and Conference Center began in 1985 and has proven to be a great success. Pictured here is the old hotel. (Courtesy Kerry Lindsey.)

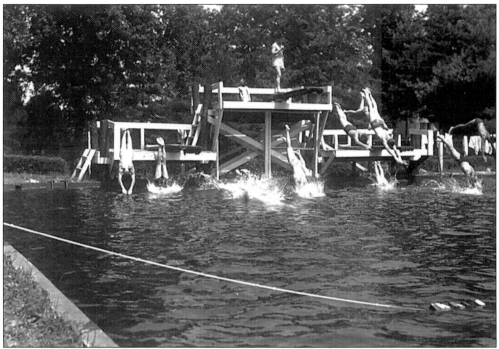

This photograph was taken c. 1930 when Highland Lake was a camp for boys. Everybody in the pool! (Courtesy Kerry Lindsey.)

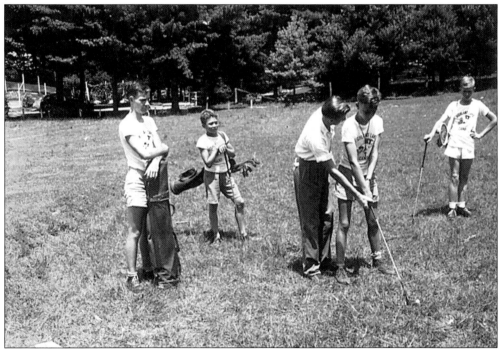

An unidentified group of boys are seen learning to play golf on the Highland Lake Golf Course c. 1930. This was the first golf course built in Western North Carolina, and it is still in operation. (Courtesy Kerry Lindsey.)

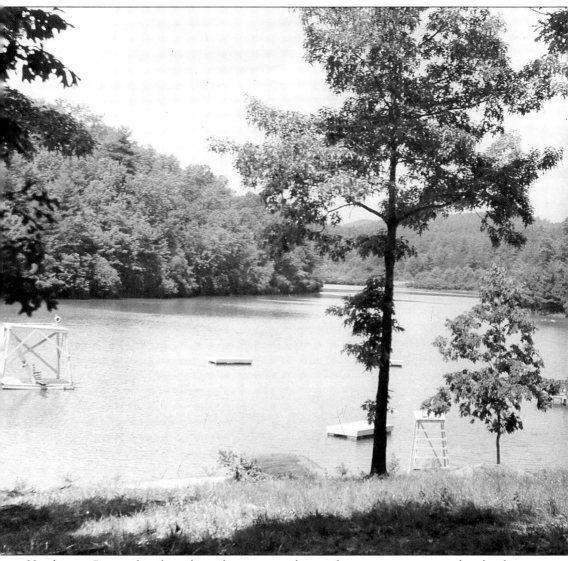

Henderson County has long been known as a haven for summer camps and today has approximately 62 camps. The settings and climate are ideal. Founded in 1926 on Wolfe Lake by Van Kussrow Jr. and H.R. Dobson, Camp Pinnacle was at first a camp for boys. After seeing their brothers having so much fun, girls started asking for their own camp time. Thereafter it was a boys' camp in July and August and a girls camp in June. Wolfe Lake is a dammed lake built in 1924, and it is a beautiful setting for summer activities. This photo of the lake was taken c. 1940. (Courtesy Van Kussrow Jr.)

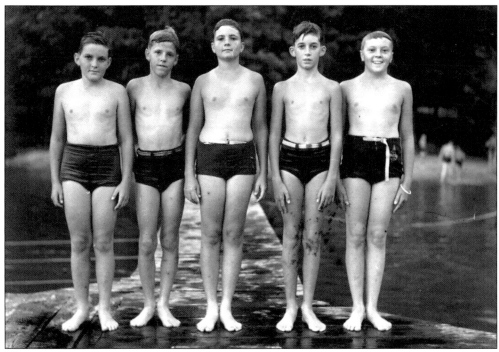

This is a photo of young swimmers at Camp Pinnacle c. 1940, with Donald Carey standing in the center. (Courtesy Van Kussrow Jr.)

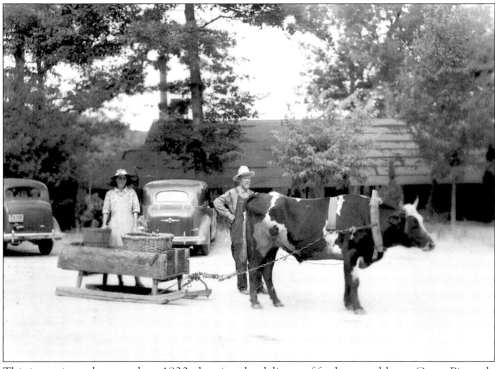

This is a unique photograph, c. 1930, showing the delivery of fresh vegetables to Camp Pinnacle via oxen and sledge. (Courtesy Van Kussrow Jr.)

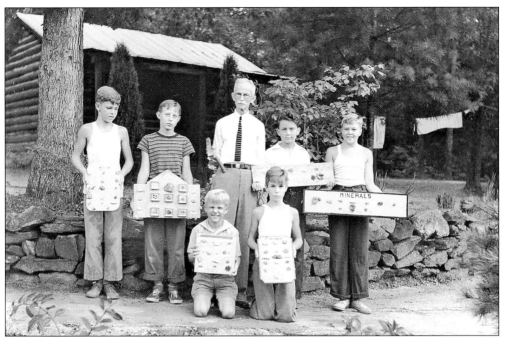

Here we have a picture of Professor Blade, director of a program on mineralogy at Camp Pinnacle c. 1935. On the professor's left is Tommy Guyton. The other boys are unidentified. (Courtesy Van Kussrow, Jr.)

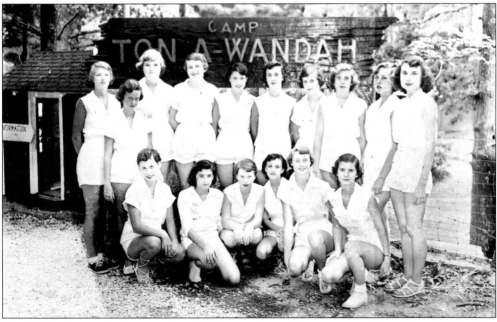

A c. 1950 photograph shows unidentified counselors at the entrance to Camp Ton-A-Wandah. The camp is located on the beautiful Lake Falls estate at 2,500 feet in elevation. The setting is typical of Flat Rock's natural beauty. In addition to the camp, the Flat Rock Music Festival is held on the grounds and partially benefits Camp Merry-times and ECO (the Environmental and Conservation Organization). (Courtesy Billy and Judy Haynes.)

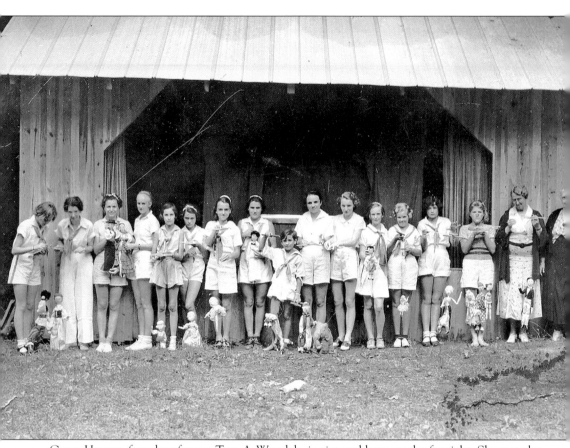

Grace Haynes, founder of camp Ton-A-Wandah, is pictured here on the far right. She was also the director of Camp Pinnacle girls' camp. She is pictured with an unidentified group of girls performing a puppet show c. 1930. (Courtesy Billy and Judy Haynes.)

This photograph is typical of the pine tree–lined drives that make Flat Rock special. Pictured is an unidentified group of campers from Camp Ton-A-Wandah c. 1950. (Courtesy Billy and Judy Haynes.)

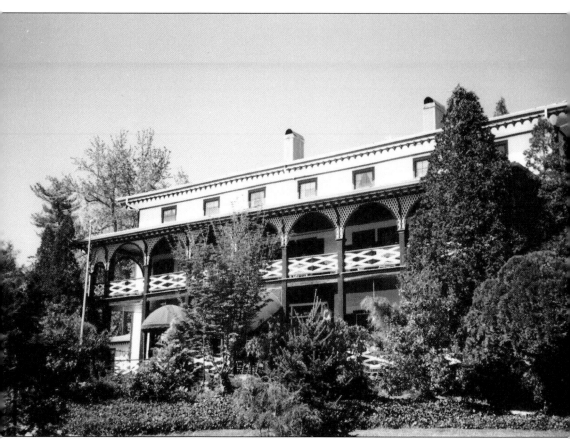

Here is a recent photograph of the Woodfield Inn, a historic property that has been so much a part of Flat Rock's history. In the early 1800s, as the number of summer visitors increased, the existing taverns (one of which was located near the entrance to The Little Hill, across from Dean's), fell far short of providing good accommodations. As a means of solving the problem it was decided that a "good, commodious tavern on or near the Main Saluda Road" should be built. Judge Mitchell King and Alexander Ramseur purchased 400 acres in the middle of the settlement. The hotel was to be built at a moderate cost and operated by Henry T. Farmer. The architect for the hotel was E.C. Jones of Charleston and the hotel was built by "Squire Farmer." Henry Farmer had come to Flat Rock as a ward of Susan Baring and spent his childhood at Mountain Lodge. He married and settled with his family in Flat Rock, becoming an accomplished builder. The group of men named as stockholders in what was to be the Flat Rock Hotel were Charles Baring, Judge Mitchell King, Andrew Johnstone, Edmund Molyneaux, William Young, Richard H. Lowndes, Matthew H. Singleton, Dr. Mitchell King, William Aiken, and Henry T. Farmer. The hotel was built c. 1853. One year later it was purchased by Farmer and it became the Farmer Hotel. He and his wife had six children, most of whom were born at the hotel. Farmer operated the hotel until his death in 1883 and was succeeded by his son Mathew Singleton Farmer. (Courtesy Historic Flat Rock, Inc.)

Five

THE GREAT OUTDOORS

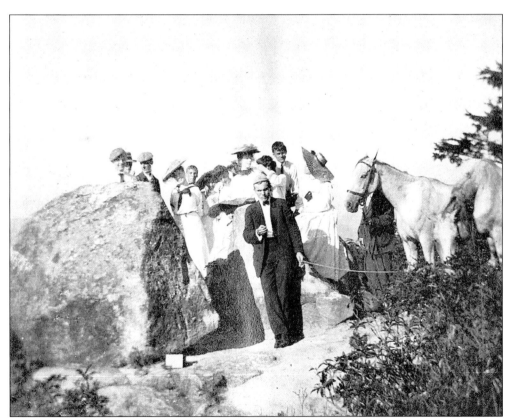

In Flat Rock's halcyon days of carefree summers, picnicking on Pinnacle Peak was a favorite outing. Travel was frequently by covered wagon pulled by great horses such as those shown in this picture. Note the gentleman in the foreground, dressed for a picnic, holding the string release attached to the shutter on the camera. (Courtesy Sara Bowers Bowen.)

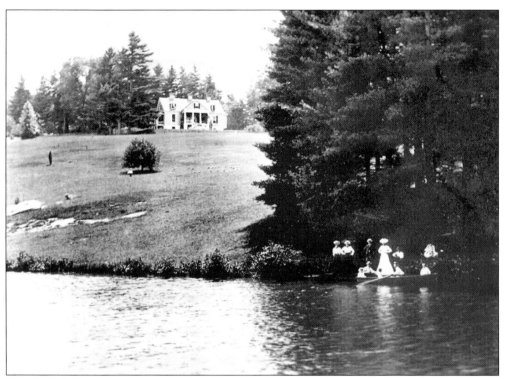

Here is a photo of a summer outing and boat ride on the front lake at the Carl Sandburg Home, Connemara. The lake has been a gathering spot for Flat Rock residents and visitors since the time of C.R. Memminger, builder of Connemara. (Courtesy Carl Sandburg Home, NPS.)

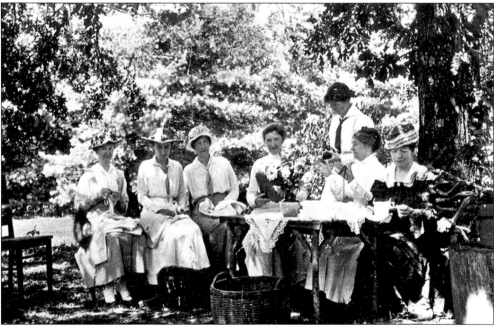

Staying cool under a tree in front of Five Oaks (the Flat Rock Inn) is the ladies sewing bee. (Courtesy Sandy and Dennis Page.)

Pictured here are unidentified riders and a companion, possibly on a picnic and quite obviously having a wonderful time. In early times Flat Rock was a very heavily wooded area, and riding was a popular—and sometimes the only—means of transportation. (Courtesy Sara Bowers Bowen.)

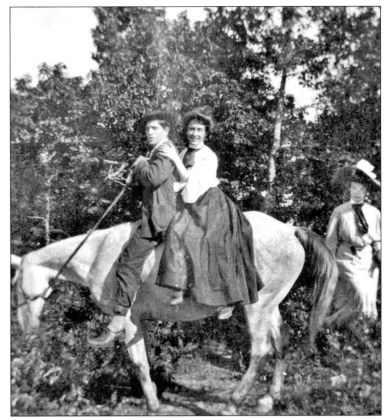

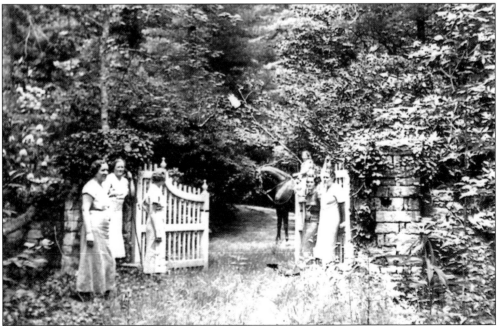

This is a photo of unidentified ladies, c. 1930, on an outing along a pathway of Chanteloup. (Courtesy Linda and Leonard Oliphant.)

Here we have Barry and Herb, mountainmen c. 1915, enjoying life in the "wilderness." (Courtesy William P. Andrews.)

This c. 1925 photo shows John Laurens, son of Charlotte Hume Simons and Henry Rutledge Laurens, on an outing close to the present home of Dr. John Laurens II. In the background is believed to be a riding stable on the Greenville Highway. (Courtesy John Laurens III.)

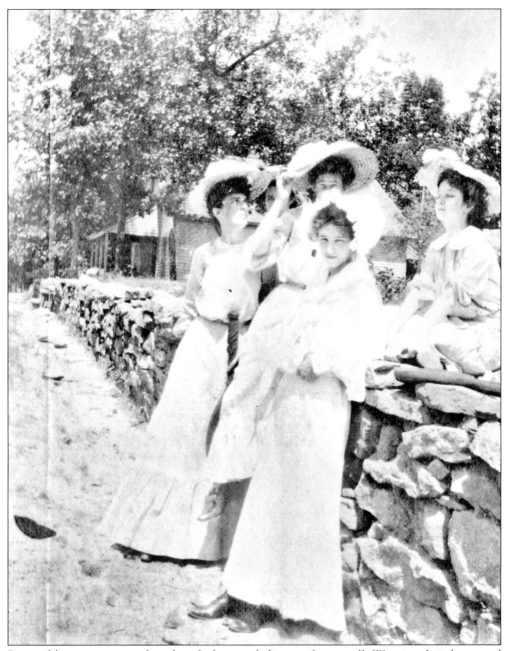

Pictured here is a group of unidentified young ladies out for a stroll. Wearing their boots and hats, they are perched on a stone wall on the grounds of Saluda Cottages. In the background two outbuildings are visible. (Courtesy Sara Bower Bowen.)

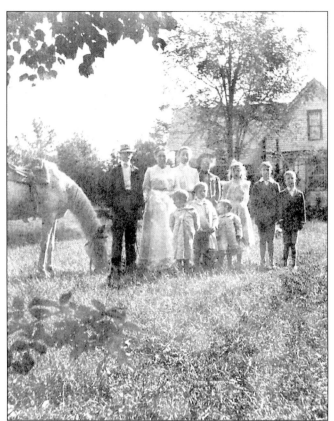

Pictured in 1903, the Laurens family on an outing in Flat Rock are, from left to right, (front row) Andrew Laurens, Rutledge Laurens, and Samuel Lord Laurens; (back row) Henry Laurens, Charlotte Hume Simons Laurens (Mrs. Henry Laurens), Martha Rutledge Laurens, unidentified, Eleanor Ramsey Laurens, John Laurens, and Frederick Laurens. (Courtesy John Laurens III.)

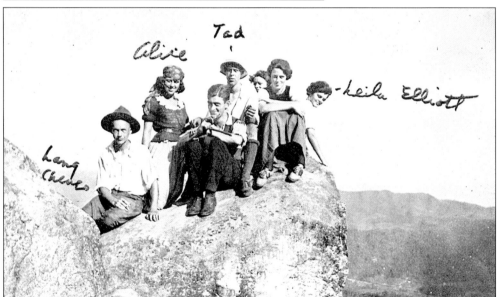

Here is another photograph of a group on top of Pinnacle Peak during a summer outing. Pictured are, from left to right, Lang Cheves, Alice Andrews, unidentified, Tad Lowndes (brother of Alice Lowndes, who was the harmonica champion of Georgia), unidentified, and Leila Elliott. (Courtesy William P. Andrews.)

Pictured here is a group of ladies having a picnic on the grass in front of Sans Souci (now Saluda Cottages). Outings of this sort were most popular, as were tennis teas and gatherings on wide open porches for conversation, dances, and socializing. Estates were far apart, but this didn't dampen the active social season. This photograph was the property of Mrs. Alexander Rose, and it is titled "The Gang, Flat Rock, NC 1897." (Courtesy John Laurens III.)

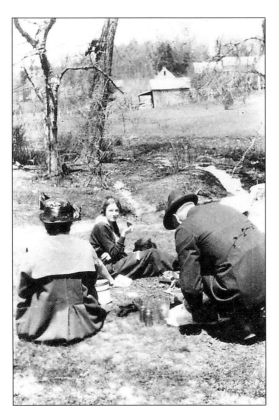

Here is a photo of the Rose family during a picnic by the old spring *c.* 1920. Shown are, from left to right, Mrs. Alexander Rose (Georgiana Hume Holmes), Emma Rose, and Alexander Rose. (Courtesy John Laurens III.)

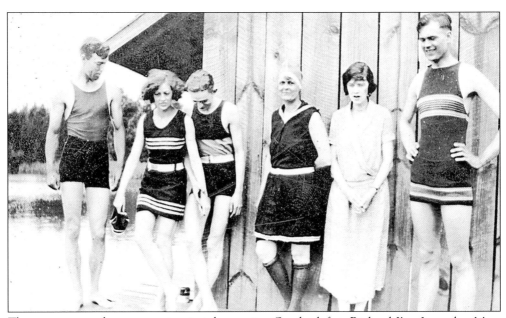

These young people are preparing to take a swim. On the left is Richard I'on Lowndes; Mary Robertson is fourth from left. The others are unidentified. (Courtesy William P. Andrews.)

From left to right, Elise ('Lise) Pinckney, Sarah Pinckney (Ambler), and Alicia Walker (Rudolph) are pictured on an excursion to Sliding Rock *c.* 1938. (Courtesy Elise Pinckney.)

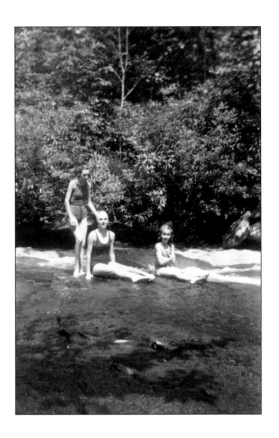

This is a picture of caretaker Massina Osten trying out the new mower at the Little Hill *c.* 1948. (Courtesy Dr. John Laurens II.)

Lucille and Quealy Walker sent this Christmas greeting showing them in front of their Flat Rock summer house. (Courtesy Sally Walker Hughes.)

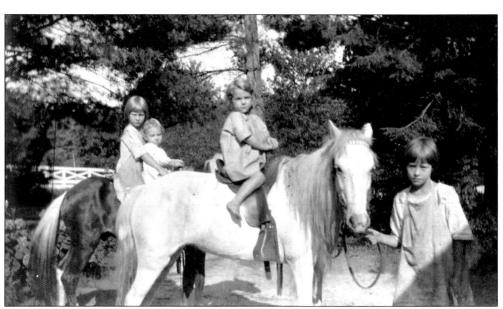

A charming photograph, c. 1928, shows Sara Pinckney (Ambler) being led by an unidentified neighbor on the white horse. On the dark horse being held by another neighbor is Elise Pinckney. (Courtesy Elise Pinckney.)

Here we have the Christmas greeting sent by the W. Gordon McCabe family showing the barns at their home Kenmure. (Courtesy Sally Walker Hughes.)

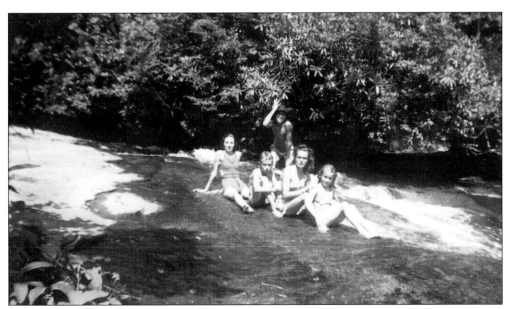

Pictured here, from left to right, is Elise Pinckney, Eddie Walker, Stewart Walker (standing) Marianna Dupont (Hanckel) and Alicia Walker (Rudolph) at Sliding Rock c. 1938. (Courtesy Elise Pinckney.)

Pictured here outside Argyle *c.* 1920 is James Roland, caretaker of the estate, exercising BB and BB (Brown Betty and Black Beauty). (Courtesy Alec C. King.)

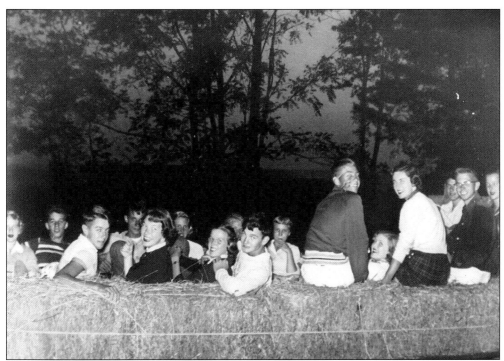

Pictured here is a hayride at McCabe's Kenmure. Sitting up on the edge are Sonny (Carl) Bommgardner, Sally Walker, and Dick Davis. Katherine McCabe is between Sonny and Sally. (Courtesy Sally Walker Hughes.)

Growing up in Flat Rock was very special. Here we have a charming photograph of Betty Lee and her little brother Wick Andrews, who appears to be armed with a croquet mallet. (Courtesy Betty Lee.)

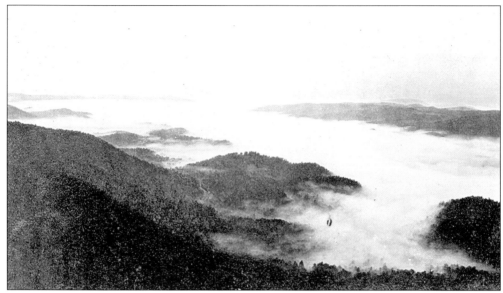

To end the chapter on the great outdoors, this photograph, taken from Pinnacle Mountain looking down on Flat Rock, tells as much as any could about the beauty of the mountains. (Courtesy William P. Andrews.)

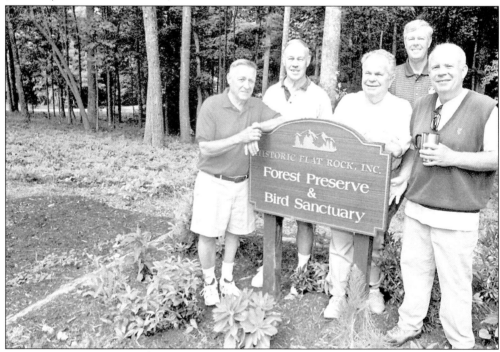

The Historic Flat Rock Nature Preserve and Bird Sanctuary is on the Greenville Highway in the center of the village. It's a delightful spot with nature trails, lovely big trees, and plantings. The park is on what once was Ravenswood Estate, owned by the Reverend John Grimke Drayton. Here we have a 2002 photograph of, from left to right, George Shipley, Bob Ogden, Oke Johnson, Wyman Rob in the back, and Kevin Tait during a volunteer cleanup at the park. (Courtesy Mike Justise; Photo Patrick Sullivan.)

Six

ATTRACTIONS

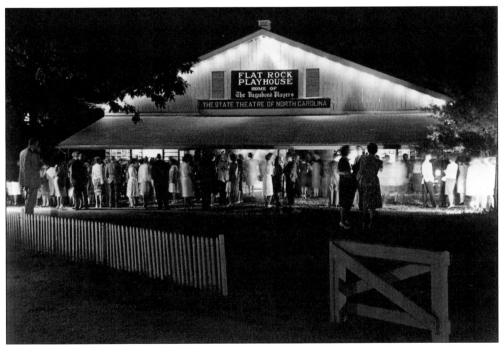

Flat Rock is fortunate to be the home of the State Theatre of North Carolina, the Flat Rock Playhouse. Robroy Farquhar, a native of England, established the first summer stock theatre in North Carolina at Rhett's Mill c. 1940. The Mill was sold and World War II interrupted the theatre, but in 1946 the Vagabond Players opened at Lake Summit and operated out of a converted school house. In 1952 they found a permanent location in the center of the village at the great flat rock. For many years plays were presented in a circus tent. The historic Lowndes House is home to the Vagabond School of Drama. This photo, c. 1960, shows the audience during intermission. The Flat Rock Playhouse is acknowledged to be one of the 10 best summer stock theatres in the country. (Courtesy Flat Rock Playhouse.)

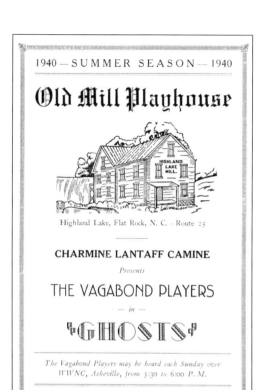

1940 — SUMMER SEASON — 1940

Old Mill Playhouse

Highland Lake, Flat Rock, N. C. · Route 25

CHARMINE LANTAFF CAMINE

Presents

THE VAGABOND PLAYERS

— *in* —

"GHOSTS"

The Vagabond Players may be heard each Sunday over
WWNC, Asheville, from 5:30 to 6:00 P. M.

Sponsored By
The Junior Department of Hendersonville Woman's Club

These are two early playbills from the Flat Rock Playhouse when it was operating out of the old Rhett's Mill (also called Highland Lake Mill.) (Courtesy Flat Rock Playhouse.)

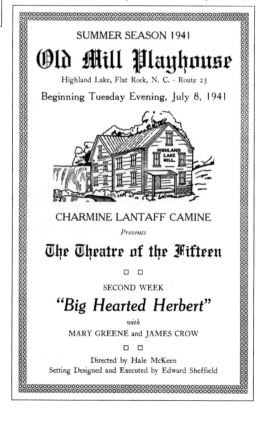

SUMMER SEASON 1941

Old Mill Playhouse

Highland Lake, Flat Rock, N. C. · Route 25

Beginning Tuesday Evening, July 8, 1941

CHARMINE LANTAFF CAMINE

Presents

The Theatre of the Fifteen

□ □

SECOND WEEK

"Big Hearted Herbert"

with

MARY GREENE and JAMES CROW

□ □

Directed by Hale McKeen
Setting Designed and Executed by Edward Sheffield

This rehearsal for a play dates from when they were being presented in the circus tent. Shown rehearsing from left to right are Anita Grannis, Pat Orr (McBane), Aaron Pittilo, Larry Bassett. (Courtesy Flat Rock Playhouse.)

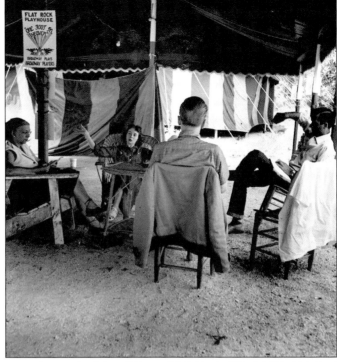

This photo is of the production *The Moon is Blue* during the summer of 1953. From left to right are Pat Orr as Patty, Will Sandy as Donald, and Earl Dossey as Slater. (Courtesy Flat Rock Playhouse.)

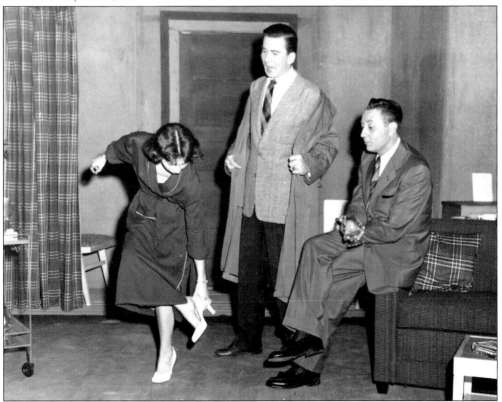

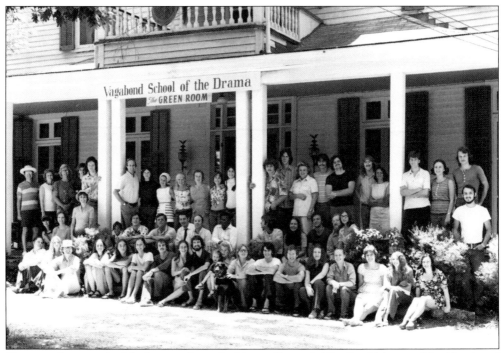

Here is a photograph of the historic Lowndes House (formerly The Rock) home of the Vagabond School of Drama. (Courtesy Flat Rock Playhouse.)

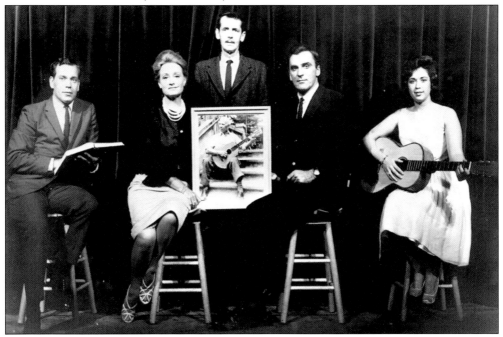

The Flat Rock Playhouse works closely with the Carl Sandburg National Historic Site, located directly across Little River Road. Here is a photo of, from left to right, Gordon Elliott, Ann Driscoll, Robroy Farquhar, Gill Rogers, and Missy Crower during a production of *The World of Carl Sandburg*. (Courtesy Flat Rock Playhouse.)

An aerial view above the Flat Rock Playhouse shows a portion of the "great flat rock." This is the largest exposed portion of the flat rock where the Cherokee met and for which the village is named. Th e Flat Rock Playhouse is the State Theater of North Carolina. (Courtesy Flat Rock Playhouse.)

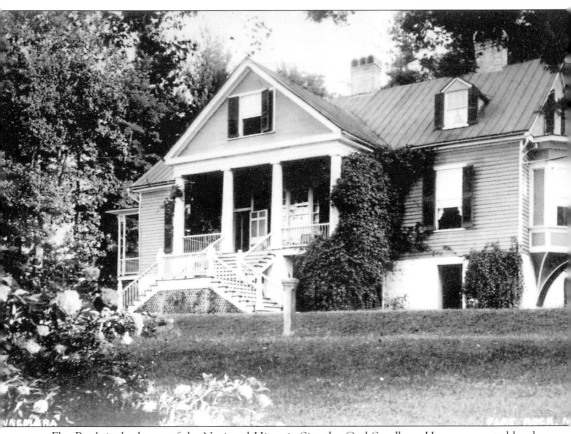

Flat Rock is the home of the National Historic Site the Carl Sandburg Home, operated by the National Park Service. As seen earlier in this book, the house was built by Christopher Gustavus Memminger and called Rock Hill. It was then the home of industrialist Ellison Adger Smyth, who changed its name to Connemara. Carl Sandburg and his family moved here in 1945 and remained here until his death. The house, barn, and grounds are open to the public and remain a shrine to Carl Sandburg. More than 100,000 people tour the house and grounds each year. After Sandburg died, the property was purchased by the Park Service, which was then given the contents of the buildings—including memorabilia and thousands of volumes of books, which remain on the shelves for all to see. The interior of the house has been kept exactly as the Sandburgs left it. This photo shows the house c. 1920. (Courtesy Carl Sandburg NHS, National Park Service.)

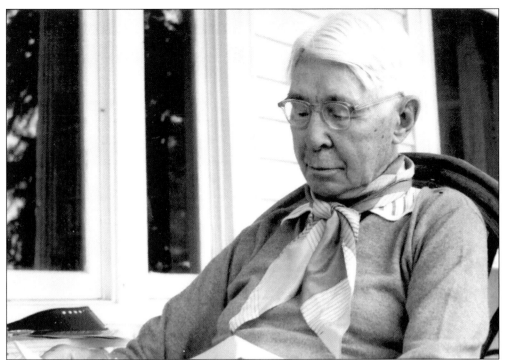

Carl Sandburg is pictured reading on the porch of Connemara c. 1960. Sandburg was a great historian and author. Another author of note, Glenn Tucker, retired to Flat Rock about the same time as the Sandburgs. Tucker wrote *Poltroons and Patriots*, *Tecumseh*, *High Tide at Gettysburg*, *Dawn Like Thunder*, and *Front Rank*, among others. The bulk of his work was done in Flat Rock, and he and Carl Sandburg were friends. Other notable authors who called this area home were Dubose Heyward (who lived on Canuga Road and who wrote *Porgy and Bess* with George Gershwin while living here) and F. Scott Fitzgerald. (Courtesy Carl Sandburg NHS, National Park Service.)

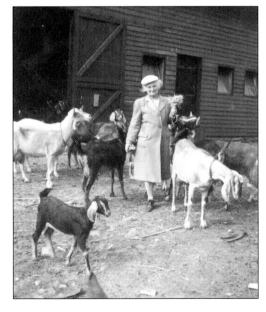

This is a wonderful photograph of Mrs. Sandburg with her prize-winning goats at the barns on the property of Connemara c. 1950. While touring the National Historic Site, you can also see offspring of these wonderful animals that are tended to this day by faithful volunteers. Mrs. Sandburg was Lillian Steichen, sister of famed photographer Edward Steichen, who spent much time in Flat Rock. He and Carl Sandburg were fast friends. The property is on the side of Glassy Mountain where there are numerous trails of varying difficulty that are open to the public. (Courtesy Paula Steichen Polega; National Park Service photo.)

presents the

Tour of
Homes
Gardens

Saturday, August 3
10AM – 4PM

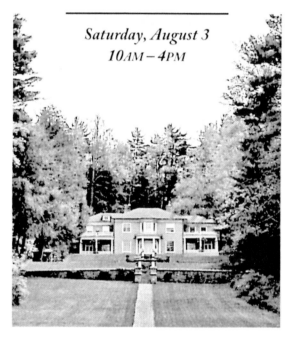

Chanteloup
c1841

All proceeds benefit the non-profit
organization Historic Flat Rock Inc
to aid in their efforts to protect and
preserve the area's heritage.

Every other year, Historic Flat Rock, Inc., hosts a Tour of Homes, a fund-raiser for the non-profit organization, whose goal is to preserve historic properties of the village. Shown here is the brochure from the 2002 Tour of Homes featuring Chanteloup, as well as other historic properties, including the Woodfield Inn and St. John in the Wilderness Church. (Courtesy Historic Flat Rock, Inc.)

Seven

PEOPLE

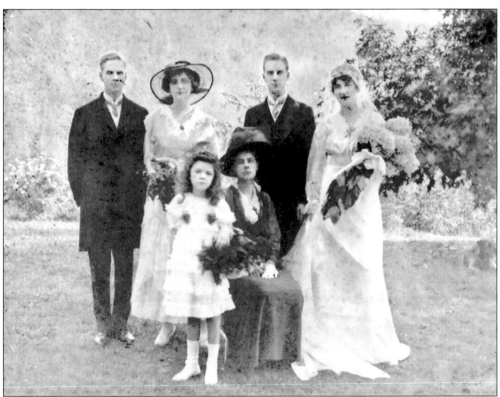

Clarice (Paine) and Glen Drayton Grimke are pictured on the lawn at Hilgay after their wedding at St. John in the Wilderness Church. On the left are unidentified wedding attendants. Seated are Emma Drayton Grimke, mother of the bridegroom, and an unidentified child. Emma Drayton Grimke and her husband, the Reverend John Drayton Grimke, built Hilgay, and Mrs. Grimke designed and planted the gardens. This photo was taken in September 1915. (Courtesy Warren Roberts III.)

This is a photo of Alexander Campbell King, taken at the steps of his home Argyle. Argyle was built c. 1829 and is still in the King family. At one time it was home to Susan Petigrew King and was where she wrote *Gerald Gray's Wife and Lily: A Novel*. This book was the forerunner of Margaret Mitchell's *Gone With the Wind*. King was solicitor general under President Wilson. (Courtesy Alec C. King and Sara Bowers Bowen.)

Pictured here is Greta Grimshawe King with her son, Campbell King, c. 1930, at their residence Five Oaks, now the Flat Rock Inn. (Courtesy Sandy and Dennis Page.)

Pictured on the far left in this wonderful old family photograph is Janice Lee, next to her mother Eliza "Lizzie" Lee, grandmother and great-grandmother (respectively) of Gene Staton. (Courtesy Debbie and Gene Staton.)

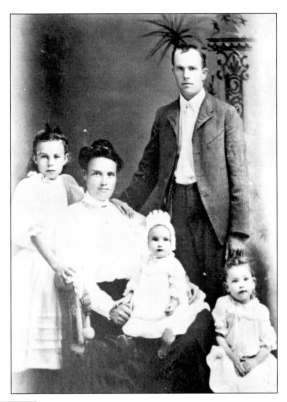

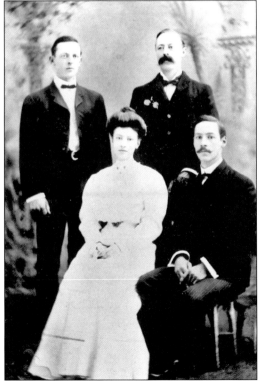

The Lowndes family c. 1900 are, from left to right, Richard I'on Lowndes, William Lowndes, (seated) Sara I'on Lowndes (Davis), and Richard Lowndes. (Courtesy William P. Andrews.)

Alice Izard Middleton Lowndes Andrews takes a respite from tennis to entertain her friend Langdon Cheves. Alice Lowndes was the Ladies Southern Singles tennis champion of 1922. (Courtesy William P. Andrews.)

Greta Grimshawe King, second from right, poses with a group of unidentified friends c. 1920 in front of Five Oaks (the Flat Rock Inn). (Courtesy Sandy and Dennis Page.)

This is a photograph of Frances Davis Andrews, who married Oscar A. Meyer from Charlotte, North Carolina. They moved to this area where Mr. Meyer ("Ock") headed construction of the Green River–Tuxedo hydro plant for Blue Ridge Power Co. Andrews was the mother of Oscar Meyer, who started Meyer's Flying Service (the Hendersonville Airport) in 1929. (Courtesy William P. Andrews.)

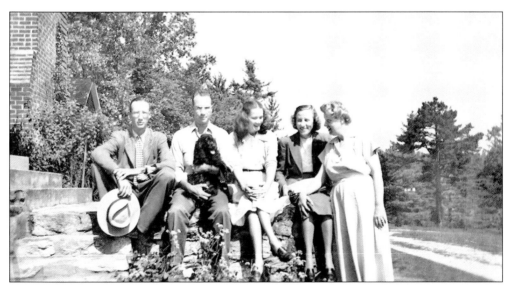

Seated on the new rock wall at The Little Hill in September 1948 are, from left to right, Franklin Davenport Laurens, Dr. John Laurens II (holding dog Pepper), Helen Scroggins Laurens (Mrs. John Laurens), Jennie Dare Aiken (Mrs. Franklin D. Laurens), and Mary Holmes Rose (Mrs. John Laurens). The Little Hill is Dr. John Laurens's permanent home. (Courtesy Dr. John Laurens II.)

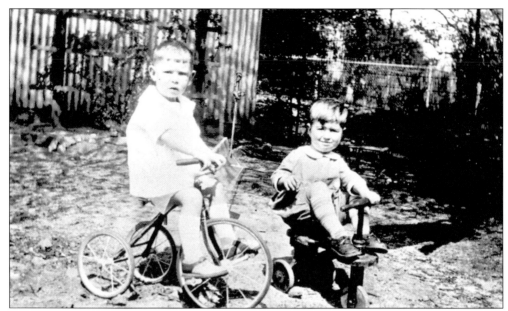

Here we have two little fellows at play *c.* 1926 on the grounds of Five Oaks (the Flat Rock Inn). On the left is Campbell King, whose parents owned Five Oaks, and on the right, Tommy Tucker. (Courtesy Sandy and Dennis Page.)

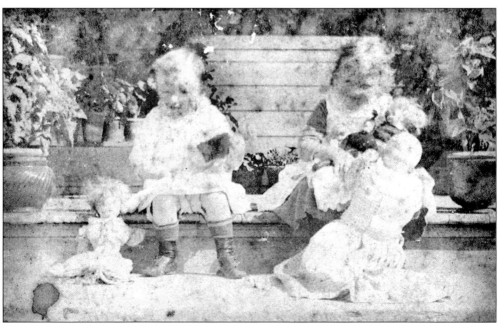

This charming photo is titled "Our Babies" at San Souci *c.* 1889. Rudolph Campbell Siegling and his older sister Effie Campbell Siegling are playing dolls. (Courtesy Sara Bowers Bowen.)

Pictured here, possibly during their first summer at Flat Rock, are Louise Pinckney (Mrs. Edward R. Pinckney) and daughters Elise (left) and Sara (right). (Courtesy Elise Pinckney.)

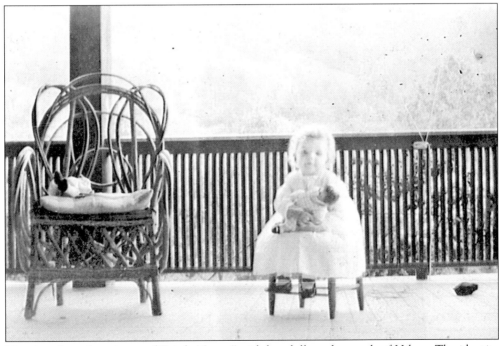

Here is a charming picture of "Little Nancy" with her doll on the porch of Hilgay. The identity of the child has been lost to time but not the charm. On the left is a handmade willow chair. (Courtesy Warren Roberts III.)

Little sisters Bettina (left) and Barbara Peace (right) play with Jojo the dog in front of the old Hollingsworth house. The Peace family owned and ran Peace's Store. The house stood to the left of the livery stable on Blue Ridge Road. (Courtesy Barbara Peace Lowman.)

With Glassy Mountain in the background, this photo shows Clarice Grimke Drayton on the grounds of Hilgay c. 1916. Her husband's family came to Flat Rock and built Hilgay c. 1914. (Courtesy Warren Roberts III.)

Celebrating Easter Sunday at The Little Hill in 1957 are, from left to right, in the rear, Helen Laurens and Dr. John Laurens II, and in front, their children Mary Rebecca (Becky), Martha Dexter (Deedee), Helen Patricia (Pat), and John III (Chip). (Courtesy Dr. John Laurens II.)

Here is a picture of Alice Lowndes with her dog and with Dulce Far Nienti in the background. Alice was a talented horsewoman and tennis player; she won the Southern Ladies Singles and the Doubles (with Emmy Mayberry McIntyre from Charleston) championships. (Courtesy William P. Andrews.)

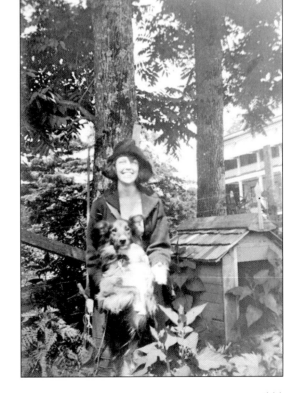

In this undated photograph Senator Hoey is greeted by Robroy Farquhar. The senator was a guest for a performance of *The Silver Whistle*, in which Farquhar portrayed Oliver Erwenter. (Courtesy Flat Rock Playhouse.)

Pictured c. 1929 is a group of unidentified children at the Old Flat Rock school. It was called the Pebbledash School because of the material on the building's exterior. (Courtesy Lewis King.)

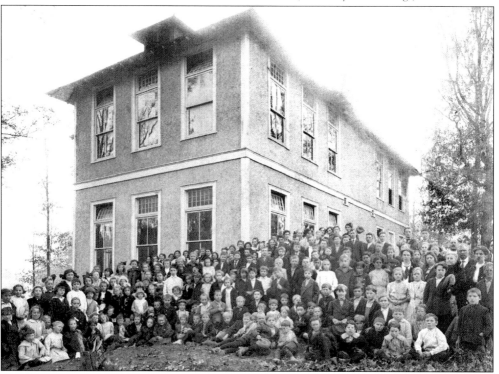

William P. Andrews Sr., far right, is pictured with his basketball team while he attended Chapel Hill. (Courtesy William P. Andrews.)

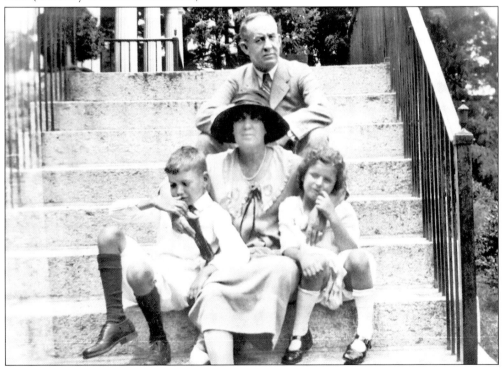

Shown here on the steps of Kenmure are Mr. and Mrs. William G. McCabe, son Edmond, and daughter Virginia. Mr. McCabe made many improvements to Kenmure (the original Glenroy, home of Dr. M. King). It had lovely gardens, 1,400 acres of beautiful land, and 23 outbuildings. Kenmure is now Kenmure Country Club, a private residential golf community. (Courtesy Mary McCabe Dudley.)

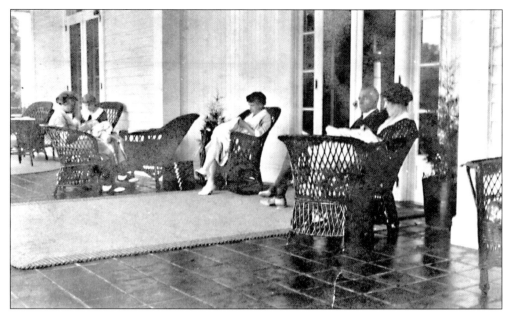

Here we have a charming photograph of the sewing circle on the lovely porch at the McCabes' Kenmure. (Courtesy Mary McCabe Dudley.)

Elise Pinckney and hostess Mrs. Alexander Schenck are pictured in the living room of Rutledge Cottage. (Courtesy Historic Flat Rock, Inc.)

Pictured in front of a huge boxwood at Pinecrest are, from left to right, Hess Waring Jenkins Montague, Hess Lebby Jenkins, Lucile Lebby Siegling Dwight, and Effie Campbell Siegling Bowers. (Courtesy Mr. and Mrs. Jeff Bowen.)

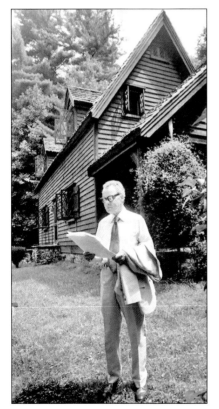

John Wesley Jones, former U.S. ambassador to Peru and past president of Historic Flat Rock, Inc., stands in front of the Stoneender House c. 1980. (Courtesy Historic Flat Rock, Inc.)

Pictured c. 1965 in front of the very unique dining room windows in their summer home, Road's End, are Lucile and Quealy Walker. (Courtesy Gracia Walker Slater.)

Each year the Blockhouse Races in Tryon usher in the spring season. In 1957 a group of picnickers from Flat Rock is about to enjoy the races. On what was obviously a chilly day, we find from left to right an unidentified child, Betty Andrews Lee, Alice Lowndes, William P. Andrews Sr., Richard Lowndes, and Leila Hopkins. (Courtesy William P. Andrews.)

The Connemara Farms championship square dance team won the championship at the Rock Island Railroad Fair in 1948. Pictured here counterclockwise from top left are Jim Hinson and Peggy Jones; Cecil Hyder and Helen Drake; Charles Stepp and Geraldine Drake (on their honeymoon); Byron Reed and Hazel Arrowood; Marvin Orr and Marilyn McClain; and Frank Mintz (with his back to the camera), the caretaker at Connemara and the caller for the group, his wife Dolly; Reynolds and Emma McGaha; and Bob Williams and his wife. (Courtesy Geraldine Collis.)

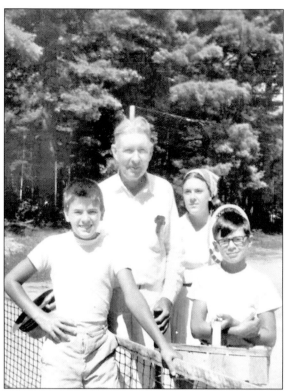

Pictured here at the Pinecrest tennis courts is tennis instructor Mr. Wadsworth with (from left to right) Lloyd, Effie, and Charlie Bowers. (Courtesy Mr. and Mrs. Jeff Bowen.)

Pictured here c. 1960 are Mrs. Lucille Jenkins Rumsey (left) and Mrs. Effie Campbell Siegling Bowers at Pinecrest. (Courtesy Mr. and Mrs. Jeff Bowen.)

Celebrating Thanksgiving together are (front row) Alice and William P. Andrews Sr.; (middle row) Elise Pinckney, Anne Mollette, Elinor Collins, and Wick Andrews (standing); (back row) two unidentified companions. (Courtesy William P. Andrews.)

Warren Roberts III and his friend Fleming Prettyman play trucks c. 1960. (Courtesy Warren Roberts III.)

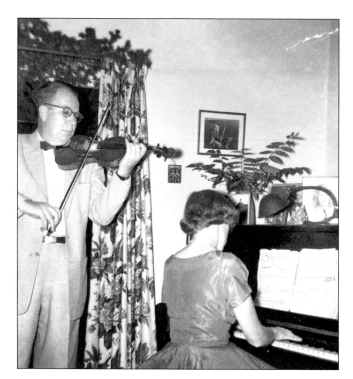

Here John Eversman, former director of Brevard College, and his daughter Nancy Kortheuer, an organist at St. John in the Wilderness, play for an afternoon church gathering c. 1962. (Courtesy John Kortheuer.)

Pictured here at a party at the Andrews' home are, from left to right, Louise Blake (back to window), Jane Angier (seated at fireplace), Campbell King (in rocker), William P. Andrews Sr., Henry Laurens (back to the camera), Newt Angier (facing the camera), and Bill Hartman. (Courtesy William P. Andrews.)

Lloyd Bowers is waiting his turn on the tennis court at Pinecrest. When he bought the estate, the tennis court had been covered over. He uncovered and refurbished the court for him and his family to enjoy. (Courtesy Mr. and Mrs. Jeff Bowen.)

The Robertsons are about to welcome their good friends and neighbors, the Gillies in August 1949. The Robertsons owned Hopewood, which is now Sherwood and owned by Mrs. Margaret Roberts. Reuben Robertson (left) was chairman of the Champion Paper and Fiber Co. (Courtesy Sally Walker Hughes.)

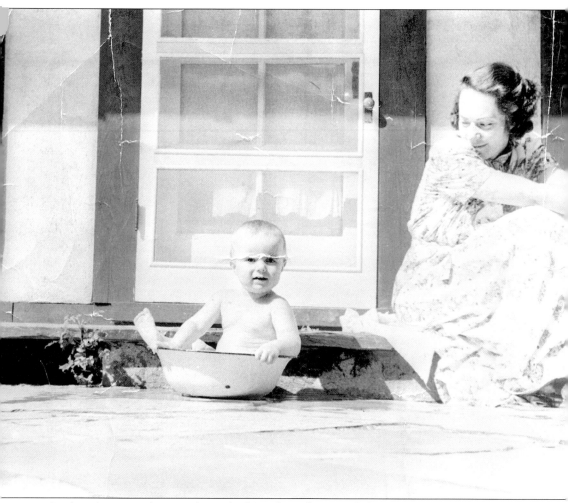

In this charming photograph we find Lucile Gillican with baby Butch (Bill) at their home Arrowhead Hill c. 1939. Arrowhead Hill was built by Walter and Lucile Gillican Walker c. 1918 and owned by them until the late 1940s, when they purchased Road's End. (Courtesy Sally Walker Hughes.)

Pictured here is Robroy Farquhar, originator of the Vagabond Players. He and his wife brought the theatre through difficult beginning times to be the Flat Rock Playhouse, the State Theatre of North Carolina. (Courtesy Flat Rock Playhouse.)

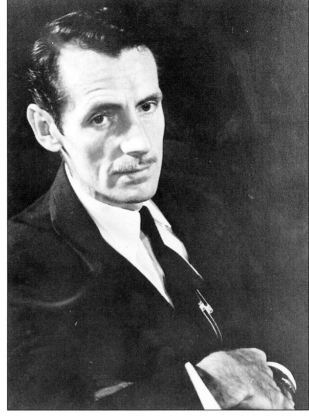

Sitting on the stone wall at their home Hilgay are Clarice and Glen Grimke with their daughter Zelda (sitting) and an unidentified child (left). The Grimkes were married at St. John in the Wilderness and are descendants of the Reverend John Drayton Grimke of Charleston. (Courtesy Warren Roberts III.)

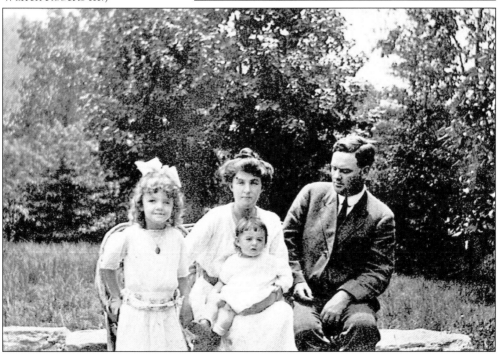

Gordon McCabe is pictured here at his home Kenmure. He is seated on the front porch with his dog Buck. McCabe was senior vice-president of J.P. Stevens Co. (Courtesy Mary McCabe Dudley.)

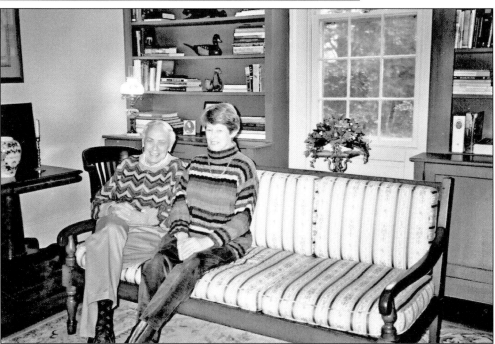

Pictured here are Gene and Debbie Staton at their home Brooklands. They are sitting on their Flat Rock sofa. Flat Rock sofas, chairs, and other useful items were made in Flat Rock for the Farmer Hotel. They are now very collectible.

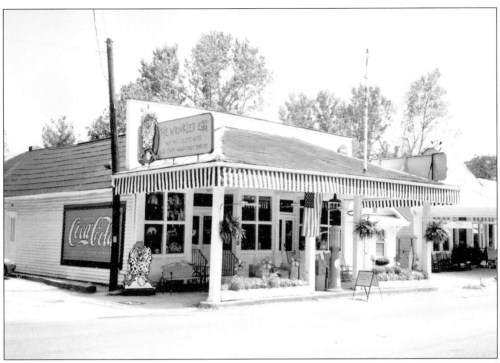

Here is a recent photograph of The Wrinkled Egg, the former Peace's Store. (Courtesy Starr and Virginia Teel.)

The Village of Flat Rock celebrates "Unity in Community" with an ice cream social every spring. Here is a photo of the celebration when it was held in front of the Flat Rock Village Office in 2002. Representatives of the armed forces were on hand, and entertainment was by the Kenmure Chorus. The event is now held at the Flat Rock Playhouse. Village residents spend a pleasant day greeting old friends and meeting new ones.

An unidentified group of Flat Rock residents enjoy the ice cream social c. 2002. Terry Hicks (right), then mayor of Flat Rock, serves ice cream. (Courtesy Pete Zamplas.)

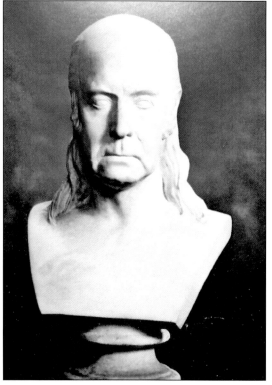

Here is the bust of Judge Mitchell King, early settler and builder of Argyle. Judge King was the president of the Medical University of South Carolina and later president of the College of Charleston. He was instrumental in getting the railroad built from the Atlantic seacoast to the inland waterway. (Courtesy Danny Ogletree.)

This is an old photo of Thornwell Hamwood Andrews, who flew the first plane over Charlotte in 1912. His nephew, Oscar Meyer, established the Hendersonville Airport around 1930. Meyer was a self-taught pilot who went on to teach countless young men to fly.

One of these young men was Jack Edney of Hendersonville. Edney joined the U.S. Air Corps and served at Kelly Field. He would ultimately serve as air attache to Ireland. (Courtesy William P. Andrews.)

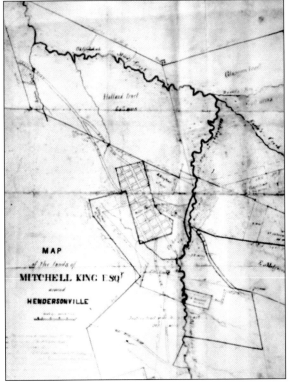

This is a recent photo of an early map of the town of Hendersonville as it was originally laid out. Flat Rock extended into what is now the City of Hendersonville, hence the donation of land for the Old Courthouse by Judge Mitchell King of Flat Rock. This map is dated October 1842 and was made by Charles de Choiseul, son of the Count and Countess de Choiseul and a licensed surveyor; it shows surrounding lands of the judge. This map hangs in the new Henderson County Courthouse.

Pictured here is the "Flat Rock Quilt." The idea of a quilt was conceived by Gretchen Highlander, wife of the first mayor. After three years of work by 16 talented needle workers, the quilt depicting the history of Flat Rock was completed. This exceptional piece was dedicated in 1999 and it hangs in the Village Offices.